# Farewell to Surrealism

## The *Dyn* Circle in Mexico

ANNETTE LEDDY
AND
DONNA CONWELL

INTRODUCTION BY DAWN ADES

THE GETTY RESEARCH INSTITUTE

**The Getty Research Institute Publications Program**
Thomas W. Gaehtgens, *Director, Getty Research Institute*
Gail Feigenbaum, *Associate Director*

© 2012 J. Paul Getty Trust
**Published by the Getty Research Institute,**
**Los Angeles**
Getty Publications
1200 Getty Center Drive, Suite 500
Los Angeles, California 90049-1682
www.getty.edu/publications

Laura Santiago, *Manuscript Editor*
John Hicks, *Production Editor*
Stuart Smith, *Designer*
Stacy Miyagawa, *Production Coordinator*

Type composed in Sentinel and Ideal Sans
Printed in China

16 15 14 13 12    5 4 3 2 1

**Library of Congress Cataloging-in-Publication Data**
Leddy, Annette.
 Farewell to surrealism : the Dyn circle in Mexico / Annette Leddy
and Donna Conwell ; introduction by Dawn Ades.
     p. cm.
 This volume accompanies the exhibition Farewell to Surrealism:
The Dyn Circle in Mexico, held at the Getty Research Institute,
2 October 2012–17 February 2013.
 Includes bibliographical references and index.
 ISBN 978-1-60606-118-3
 1. Arts, Modern—20th century—Exhibitions. 2. Paalen, Wolfgang,
1907–1959—Friends and associates—Exhibitions. 3. Dyn
(Coyoacán, Mexico)—Exhibitions. 4. Art movements—History—
20th century—Exhibitions. I. Conwell, Donna. II. Getty Research
Institute. III. Title.
 NX456.L377 2012
 709.04'407479494—dc23
                    2012004547

Front cover: The Dyn sign, detail from the cover of *Dyn*, no. 3
(1942). See this volume, p. 19, fig. 9.
Back cover: Wolfgang Paalen in his studio, 1942, gelatin silver
print, 25.4 × 20.3 cm (10 × 8 in.), Museo Franz Mayer, Archivo
Wolfgang Paalen. Photograph by Walter Reuter. Courtesy
Archivo Fotográfico Walter Reuter. Works of art in the back-
ground are (left to right): *The Cosmogons* (1944), left panel of the
triptych *The First People from Space* (1941–44), and *Project for
a Monument* (1944).
Frontispiece: Wolfgang Paalen (Austrian, 1905–59), *Space Person*,
see this volume p. 16, fig. 5.

This volume accompanies the exhibition *Farewell to Surrealism:
The* Dyn *Circle in Mexico*, held at the Getty Research Institute,
2 October 2012–17 February 2013.

# CONTENTS

While Frida Kahlo, Diego Rivera, and other Mexican artists of the 1930s and 1940s are well known, the group of European émigrés and Latin Americans who collaborated on the avant-garde journal *Dyn* in Mexico in the 1940s remains relatively obscure. The goal of this exhibition and catalog is to present to the North American public these artists, their work, and their narrative, and to follow their complex geographic and aesthetic trajectories by analyzing *Dyn*. This rare, lavishly illustrated journal is an important sourcebook for twentieth-century Latin American surrealist art.

The story begins in Paris—where most of these artists first gathered as surrealists in André Breton's circle—and moves variously through New York, Canada, and Peru, culminating in World War II–era Mexico City, where the artists reinvented themselves in opposition to both Bretonian surrealism and Mexican muralism. Transformed by the mysterious pre-Columbian artifacts and monuments that suffused the landscape, distressed by the failure of political ideology, and inspired by discoveries of physicists of the day, they set out to define theoretically and creatively a new direction for art.

Recent years have witnessed the production of much-needed new scholarship about *Dyn* and its editor, Austrian painter and theorist Wolfgang Paalen. In 2000, Christian Kloyber published the first complete reprint of *Dyn,* which was accompanied by a selection of brief commentaries. Since then, impressive studies by Amy Winter, Andreas Neufert, Gavin Parkinson, and Courtney Gilbert have enriched our understanding of this unique publication.

In spite of this new scholarship, no attempt has until now been made to closely analyze the presentation of the paintings and photographs in *Dyn*. This catalog and exhibition show the value of the journal for revealing not only the theory behind the artworks on its pages but also the process painters engaged in as they integrated disparate kinds of imagery. They reveal the dialogue with surrealist notions of photography that is embedded in the selection and presentation of the journal's photographs. Consequently, our understanding of *Dyn*'s impact, and its subsequent influence on a large number of artists, is significantly decoded.

*Dyn* forms part of the Getty Research Institute's Latin American collections, and archival material about the *Dyn* circle derives primarily from the papers of Peruvian literary figures César Moro and Emilio Adolfo Westphalen. Past GRI exhibitions on Latin America have focused on the photographic archives depicting the Mexican Revolution and nineteenth-century archaeological expeditions; this exhibition is the first to develop from the archives of writers and editors. It grew out of an initiative that began in 2009, when the GRI invited a group of international scholars to form a research project with members of our staff in order to study and publish the collections pertaining to surrealism as it developed and changed in the context of Latin America. This project has thus far produced a symposium titled "*Vivísimo muerto:* Debates on Surrealism in Latin America"; a volume of papers given at that symposium; a digital project that makes available an online version of *VVV, Dyn*'s New York counterpart; and now an exhibition and catalog—all of which express the GRI's ongoing commitment to the art history of Latin America.

*Thomas W. Gaehtgens*
Director
Getty Research Institute

# ACKNOWLEDGMENTS

The seed of this publication was planted in 2009 when Getty Research Institute (GRI) director Thomas Gaehtgens and Mexico City–based scholar Rita Eder came together to discuss how the GRI's extensive collections of Latin American surrealist journals and related papers could be utilized to produce new scholarship about the dissemination of surrealism in Latin America. Together they initiated a workshop that introduced an international group of scholars to the GRI staff. This workshop became, with the critical support of GRI deputy director Andrew Perchuk and manager of research projects Rebecca Peabody, the Surrealism in Latin America project, a multiyear research initiative that produced an international symposium and related publication, as well as this catalog and exhibition. We are most grateful for the support, encouragement, and advice of the group of researchers who participated in the Surrealism in Latin America project. They include Maria Clara Bernal, Rita Eder, Ilene Susan Fort, Claudia Mesch, Graciela Speranza, John Tain, and Yolanda Westphalen. Special thanks go to Daniel Garza Usabiaga, whose scholarship on *Dyn* first introduced us to its importance, and to Dawn Ades, whose groundbreaking scholarship on surrealist journals shaped our thinking and who served as exhibition adviser, wrote a perfect introduction, and provided expert advice at every stage of development of this initiative.

Attempting to understand how surrealism was transplanted, took root, and flowered as the unique movement it became in Latin America has taken us on a long and absorbing journey. Our specific focus on *Dyn* dates back to the 2009 workshop. In setting out materials of interest from our collections, we saw *Dyn* for the first time and marveled at its prescience and beauty. The participants in that workshop have remained wonderful colleagues, friends, and resources, as have the broader group of participants in the 2010 symposium, "*Vivísimo Muerto:* Debates on Surrealism in Latin America," including Matías Ayala, Kent Dickson, Terri Geis, Andrea Giunta, Andreas Neufert, Gavin Parkinson, and Amy Winter.

Developing the exhibition involved several presentations and critiques with our curatorial colleagues at the GRI, and for their time and commitment to excellence we would like to thank all of them, especially Lucy Bradnock, Thomas Gaehtgens, Marlyn Musicant, Andrew Perchuk, and Marcia Reed. For helping to bring the exhibition from idea to event, we are grateful to Lauren Edson, Michael Lira, Isotta Poggi, and our colleagues in Conservation and Digital Services.

This publication could not have happened without the support and strategic planning of Gail Feigenbaum and Michele Ciaccio in GRI Publications. Rebecca Zamora's research assistance and attention to detail resulted in an excellent checklist and a valuable history of *Dyn*'s production. Lucy Bradnock and Laura Santiago gave invaluable editorial advice on the manuscript, John Hicks handled production editing, and Jannon Stein worked tirelessly on procuring rights and permissions to publish the images, which were expertly shot by Jobe Benjamin, John Kiffe, and Christine Nyugen. We would also like to thank Raquel Zamora for research assistance at various crucial junctures. For his excellent design of this publication, we would like to thank Stuart Smith. Stacy Miyagawa attended meticulously to the details of production.

Thanks are also due to the many international institutions and collectors who loaned objects and helped us to locate and research material, including especially the following: Archiv Paalen, Casa Luis Barragan, Centro Nacional de Investigación, Documentación, e Información de Artes Plásticas, Luchita Hurtado Mullican, Pilar Garcia, Terri Geis, Mrs. Anna Alexandra Gruen, the J. Paul Getty Museum, the Los Angeles County Museum of Art, Lucid Art Foundation, Museo de Arte Moderno, Museo Carrillo Gil, Museo Franz Mayer, Museo Universitario de Arte Contemporáneo, Mr. and Mrs. Fernando Violante, and Adriana Williams. We offer a special thanks to Teresa Arcq for all her help in connecting us with lenders and archives.

*Annette Leddy and Donna Conwell*

REBECCA ZAMORA

From 1942 to 1944, *Dyn* was edited and published in French and English by Wolfgang Paalen in Mexico.[1] Edward Renouf served as assistant editor for the first five issues and Jacqueline Johnson as literary editor for the sixth, and final, issue. The journal attracted a number of distinguished contributors, artists, and thinkers of the day, including Manuel Alvarez Bravo, Alexander Calder, Alfonso Caso, Miguel Covarrubias, Carlos Mérida, Henry Moore, César Moro, Robert Motherwell, Gordon Onslow Ford, Gustav Regler, and Eva Sulzer.

According to scholar Amy Winter, Paalen established *Dyn* with financial backing from "Eva Sulzer and Octavio Barreda, brother-in-law of Isabel Marín, Paalen's Mexican lover."[2] The journal had a small but effective output, with a print run of sixty for the first issue.[3] Special to that issue, copies 1–20 contained a woodcut hand printed in three different tones on Chinese paper and were signed by Paalen. Unfortunately, the entire print run is not documented consistently, so numbers vary widely; for example, Gavin Parkinson states that each edition had a print run of 1,500.[4] The first three issues were printed by Imprenta Aldina, Mexico City, and the final three were produced by Talleres Gráficos de la Nación, also in Mexico City. All six issues reflect the experienced hand of Francisco Díaz de León, who provided the typographical layout and created a number of the engravings, including the cover for issue no. 6.[5]

Although written and published in Mexico, *Dyn*'s first two issues were distributed exclusively through Gotham Book Mart in New York City. For the third issue, distribution was broadened to include a representative for England, A. Zwemmer in London, while Ediciones Quetzal in Mexico City managed distribution in Latin America. Ediciones Quetzal had a bookstore[6] on Pasaje Iturbide 18 and employed César Moro, who ensured the presence of *Dyn* among that store's products. The double issue (nos. 4–5) and issue no. 6 were available through a second New York vendor, Wittenborn & Co. Books on the Fine Arts. Winter and Matthew H. Robb note that *Dyn* could also be found at the Wakefield and Weyhe galleries in New York and the Galerie Maeght in Paris.[7] These galleries and stores were instrumental in promoting *Dyn,* helping it to gain attention and inspire a variety of people, such as Lee Mullican (who first saw the journal in the Honolulu Academy of Art's library)[8] and "Douglas Newton, Nelson Rockefeller's curator of New York's first Museum of Primitive Art and chief curator of ethnographic collections at the Metropolitan Museum of Art…[who] first saw *Dyn* in London, when the philosopher G. E. Moore showed it to him."[9]

### Notes

**1.** The Getty Research Institute's copies of *Dyn* originate from more than one collection, including the Gloria de Herrera papers (acc. no. 980024) and the César Moro papers, ca. 1925–87 (bulk 1925–56; acc. no. 980029), and the Lawrence Alloway papers, 1935–2003 (2003.—.46 ADD1).

**2.** Amy Winter, *Wolfgang Paalen: Artist and Theorist of the Avant-Garde* (Westport, Conn.: Praeger, 2003), 123. This information is based on Winter's interview with Doris Heyden, a contributor to *Dyn,* who was a close friend of the Paalens and Manuel Alvarez Bravo's wife (151n2).

**3.** This is according to a note on the inside back cover of *Dyn,* no. 1 (1942).

**4.** Gavin Parkinson, *Surrealism, Art and Modern Science* (New Haven: Yale Univ. Press, 2008), 159.

**5.** Typographical credit appears only in nos. 4–5 and 6; however, a couple of publications offer details concerning Díaz de León's involvement with all six issues of *Dyn.* See *Mexico Illustrated 1920–1950* (Mexico City: Editorial RM, 2010), 228, 343–344; and *Diseño gráfico en México, 100 años, 1900–2000* (Mexico City: Artes de México, 2010), 146.

**6.** The bookstore also became known as a meeting place for French expatriates and Francophiles, in addition to offering many publications that were French and Spanish in origin; see Fabienne Bradu, "Bartomeu Costa-Amic," *Vuelta* 253 (1997): 45.

**7.** Winter, *Wolfgang Paalen,* 123; Matthew H. Robb, "Only Collect," *Record of the Art Museum, Princeton University* 64 (2005): 46–47.

**8.** Lee Mullican, oral history interview by Paul Karlstrom, 22 May 1992–4 March 1993, Archives of American Art, Smithsonian Institute, Washington, D.C.

**9.** Winter, *Wolfgang Paalen,* 123.

DAWN ADES

During the Second World War, extensive networks in the Americas linked exiled writers and artists from Europe with one another and with their indigenous counterparts. Among the refugees from Europe were many of its cultural leaders, poets, and artists, who sought to rebuild their lives with no certainty that they would ever return to the Old World. These included several of the surrealists and former surrealists, who dispersed throughout the Americas, with the largest numbers settling in Mexico City and New York.[1] From the exiles in these two cities came two of the most remarkable journals of the twentieth century: *Dyn* (Mexico, 1942–44) and *VVV* (New York, 1942–44) (fig. 1). Together with another New York–based journal, *View* (1940–47), they present a vivid picture of poetic and artistic activities in a contested terrain, where surrealism struggled to find its voice in a strange land and where its influence, though often denied, was to be crucial to the postwar renaissance of art in the United States. The journals reflect the bitter disputes and aesthetic rivalries that characterize this period of cultural and political uncertainty.

With most of Europe shut down under the German occupation or under fascist control, the Americas became the primary ground for the "little magazines" concerned with modern art and literature and with the avant-garde in general. It was not the magazines, though, that "discovered" new writers, poets, and so on. Rather, it is the "new" writers and artists who *make* the magazines, not the other way round, as they struggle to get a public.[2] Publishing a magazine or journal, however modest, was a vital sign of artistic and intellectual life for groups and even individuals. Every surrealist group in the Americas signaled its existence with a journal: take, for example, *Mandrágora* (1938–43) from Chile; and *El uso de la palabra* (1939), jointly edited from Lima and Mexico City by Emilio Adolfo Westphalen and César Moro. *VVV*, coordinated from New York, "*d'orientation surréaliste*," was intended to "set up a

network of correspondents throughout the Americas who will inform the public about everything that is happening in their respective countries, in the realm of poetry, art, philosophy or any other realm that seems to them essential."[3] *VVV* was thus conceived as the hub of a revitalized surrealism and was to include contributions from groups or individuals from, among other places, Chile, Martinique, Peru, Guatemala, Brazil, and Mexico as well as the United States. It welcomed fellow surrealist publications such as *Arson* (London), the aforementioned *Mandrágora*, and *Tropiques* (Martinique), but also covered in its "Review of Reviews" were journals of all denominations active at the time, such as *View, Kenyon Review,* and *Cuadernos americanos* ("by far the best review appearing in Mexico").[4] Journals like the latter were ambivalent or indifferent to surrealism; *Dyn*, however, was actively opposed to it, at least in theory.

Of the new journals that appeared in the Americas during the Second World War, *Dyn* was one of the most ambitious intellectually and adventurous artistically. Largely the work of one man, Wolfgang Paalen, *Dyn* articulates key aspects of the cultural drama of European exile in the Americas. Paalen, having been a member of the surrealist movement in Paris before the war, renounced it in the first issue of *Dyn*. His secession sent a shock wave through the American surrealist groups and forced several individuals, including César Moro and Gordon Onslow Ford, to choose between André Breton and Paalen. Moro, who had been bitterly disappointed that Breton did not settle in Mexico, was close to Paalen, with whom he had organized the *Exposición internacional del surrealismo* in Mexico City in 1940. Moro's letters from Mexico to his fellow surrealist poet Emilio Adolfo Westphalen, in Lima, give a vivid picture of Paalen's intense artistic and intellectual activity in the months leading up to *Dyn*'s launch. "Paalen is writing a book about Alaska; I've read the first 50 pages. Very fine. He is working enormously hard, and of course has the means to

live without financial worries."[5] Paalen was painting furiously as well but initially wouldn't show his work to anyone. Finally, in October he showed Moro his new, "magnificent" paintings and gave him one in exchange for a Peruvian vase: "one of the most beautiful and surrealist of Peruvian vases, it's a representation of the moon: magnificent."[6]

In November 1941 a letter from Breton in New York reached Paalen, soliciting Paalen's collaboration and projecting surrealist activity across the globe that would also involve Moro and Westphalen. Moro communicated this invitation to Westphalen in Peru, urging his friend to agree to be surrealism's representative in Peru. He himself, though, was already committed to Paalen, who "is separating himself from the movement and thinking of starting a review."[7] Moro's reasons for siding with Paalen are, he tells Westphalen, purely personal, although later he expressed his disappointment that surrealism had not found the energy to renew itself and was too dogmatic. Moro also reports that Paalen, a consummate theoretician, has a quarrel with Marxism, an important factor, by implication, in the latter's rejection of surrealism.

Paalen had already voiced criticism of the movement in the "all-surrealist number" of *View* edited by Nicolas Calas (1941): surrealism's error, according to Paalen, was "that it conceded to politics a kind of reality apart, outside surreality (somewhat as children concede a reality apart to the world of 'grown ups'), that it accepted too readily a new 'thing in itself,' as an absolute, the reality of materialist interpretation and with it that of political matters."[8]

Paalen's quarrel with surrealism's Marxism was carried into the pages of *Dyn* with an "Inquiry on Dialectic Materialism." Paalen believed, as he wrote in the text following the Inquiry, "The Dialectical Gospel," that "dialectic materialism" was a deadweight holding Marxism back from "all that is most progressive in modern thought" and constituted "an obstacle to a truly revolutionary fusion with

**Fig. 1.**      **Cover of *VVV*, no. 1 (New York, 1942)**
Design by Max Ernst
(German, 1891–1976)

modern science, art and philosophy."[9] The Inquiry's questions, addressed initially to a number of scientists, philosophers, and writers, including Breton and Albert Einstein, turned on whether the "dialectic method" was a "scientific method of investigation."[10] Of those solicited, Breton was among those who did not answer; Einstein wrote to explain why he did not wish to express an opinion; Bertrand Russell rejected the "metaphysics of both Hegel and Marx," writing that "Marx's claim to be 'science' is no more justified than Mary Baker Eddy's"; Meyer Schapiro observed reasonably that the questions "were not inspired by a primary concern with the theoretical and practical problems of socialism." Paalen's objective was to prove that the dialectic was neither scientifically nor philosophically valid and that the "revolutionary effort" should, rather, be based "as much as possible on scientific knowledge, instead of wasting it in futile efforts to turn the world upside down by a miracle."[11]

Paalen's real target, though, is surrealism itself; he strikes at the notion of the "resolution of antinomies," such as dream and waking, conscious and unconscious, which lay at the heart of the movement. As if to underline the basic difference between *Dyn* and *VVV*, the New York journal's opening statement explains that the three *V*s forming the title of the journal were themselves conceived in terms of a dialectic, the first two standing for the reality principle and the pleasure principle, "the resolution of their contradiction tending only to the continual, systematic enlargement of the field of consciousness towards a total view/VVV."[12]

*Dyn*'s opening statement stresses its independence—*Dyn* "neither belongs to, nor proposes to establish an 'ism,' group or school."[13] Paalen's essay "Farewell au surréalisme" pays generous homage to the ism he had belonged to, but states that he could no longer accept its philosophical base and that he did not believe surrealism could formulate the "raison d'être of art." His own solution in terms of art—his belief that art and science are inseparable—is discussed in the present volume by Annette Leddy. Paalen's essays and paintings in *Dyn*, although largely overlooked in histories of postwar American art, played a significant role in its genesis and seem to provide the "missing link" between surrealism and abstract expressionism.[14]

Paalen planned *Dyn* as a long-running, wide-ranging journal of modern art that was to appear six times a year, with full-page color reproductions as well as poems and articles, and an original woodcut in the first sixty copies of each issue. He probably had in mind as a model the luxurious Paris journal *Minotaure* (1933–39), in whose final issue Paalen himself figured quite prominently.[15] *Minotaure*, better funded than previous surrealist journals, was able to incorporate diverse visual material, including a spectacular variety of photographs. Its final issue had also included André Breton's "Souvenir du Mexique" with photographs by Manuel Alvarez Bravo, whose work was to appear in *Dyn* and the Mexican journal *El hijo pródigo*. Both *Dyn* and *Minotaure* aspired to the kind of far-reaching cultural engagement that could encompass anthropology, archaeology, popular culture, and modern art. *Minotaure*'s final issue had included Kurt Seligmann's "Entretiens avec un Tsimshian," together with photographs by Seligmann of a Nootka cemetery and photographs from the National Museum, Ottawa, of Haida sculptures and of a ceremonial dance staged at Bella Coola (fig. 2).[16] There is a continuity between these and the materials gathered by Paalen, Alice Rahon, and Eva Sulzer during the trip they made to British Columbia and Alaska in 1939, itself partly inspired by Seligmann's earlier visit. Seligmann's exchange with the Tsimshian, in which European and Tsimshian myths and mythological heroes were compared, "familiarizes Northwest Coast culture, simultaneously exoticizing that of Europe. The text laments the erosion of traditional Northwest Coast life in the face of Westernization."[17] The *Minotaure* photographs mourn the passing of a civilization.

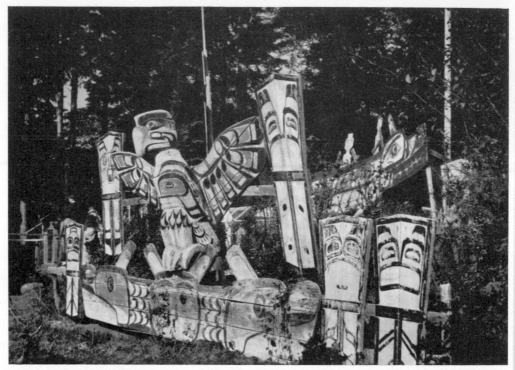

CIMETIÈRE NOOTKA, ALERT BAY, COLOMBIE BRITANNIQUE

Photo Kurt Seligmann

# ENTRETIEN AVEC UN TSIMSHIAN

par Kurt SELIGMANN

*Arrivé au port, le capitaine me dit de couper mes moustaches.*

ADALBERT DE CHAMISSO
« Voyage autour du monde »

Dans sa fumerie où pendaient des filets rouges de saumon, l'Indien Tsimshian, après m'avoir expliqué les origines de sa famille, me demanda si, en Europe, nous n'avions pas des ancêtres qui, comme les siens, avaient combattu des monstres?

Je lui racontais quelques exploits de nos héros mythologiques, et j'ajoutai que souvent ils avaient combattu pour délivrer des femmes, retenues captives, ou menacées d'être dévorées par un être surnaturel.

L'Indien voulut savoir si dans la suite les femmes

avaient enfanté des monstres? Et il hocha la tête quand je lui dis qu'aucune d'entre elles n'avait eu des rapports sexuels avec son ravisseur.

J'expliquai à l'Indien que le sens originel de nos mythes est devenu inintelligible. Seuls quelques détails essentiels de ces hauts faits ont résisté aux déformations. Il se peut fort bien, en effet, qu'à l'origine ces vierges délivrées aient eu le même caractère que les femmes ancêtres des Indiens.

Vos minotaures, vos dragons et vos monstres marins,

**Fig. 2.**

**Kurt Seligmann
(American, b. Switzerland, 1900–1962)**
*Nuu-chah-nulth [Nootka] Cemetery, Alert Bay, British Columbia,*
black-and-white photograph accompanying Seligmann's text "Entretiens
avec un Tsimshian" (Conversation with a Tsimshian)
From *Minotaure*, nos. 12–13 (1939): 66

Similarly, Sulzer's extraordinary photographs (many of which were reproduced in *Dyn*), taken during the trip with Paalen and Rahon, show totem poles in abandoned Haida villages and graves and carved sculptures overgrown by the forest. Most of those photographs or pictures illustrating Paalen's texts in *Dyn* that do contain people date from the eighteenth or nineteenth century.

Despite Paalen's theoretical rejection of surrealism and the undoubtedly new direction taken by his paintings, some of his key beliefs—the imagination as the most precious human faculty, the associative powers of the unconscious, and above all his passionate interest in the art of the First Nations and of pre-Columbian America—are still cognate with surrealism. As Onslow Ford said, "*Dyn* was a continuation of surrealism with a modified point of view rather than a farewell."[18]

Although produced from Mexico City, *Dyn* was to an extent aimed toward English-speaking North America and French-speaking surrealist exiles, with Gotham Book Mart in New York as its exclusive representative for the first two issues. *VVV* and *View* were both published in New York. *VVV* was the only bona fide surrealist journal of the three and functioned mainly, though not exclusively, as the organ of the refugee group. Its editor was the young American artist David Hare (with Breton himself and Max Ernst as editorial advisers).[19] *View* started publication in September 1940 and was edited throughout its life by Charles Henri Ford. Its approach to contemporary art and literature was open and eclectic, but it also kept up a close, if ambiguous, relationship with surrealism and was a major platform for surrealist artists. It was *View* that welcomed Breton upon his arrival in New York and published special issues devoted to Ernst, Yves Tanguy, and eventually Marcel Duchamp. Not, however, being under Breton's direct control "led to a certain amount of friction between his coterie and the circle around Charles Henri Ford."[20] For instance, when Benjamin Péret sent to *View* a fragment from the introduction to his *Anthologie des mythes, légendes et contes populaires d'Amérique,* Breton responded with a furious telegram asking him to withdraw it. It was, Breton's biographer Henri Béhar said, "as if in Paris he had sent a text to Cocteau."[21]

Generous as *View* was in its coverage of the European surrealist exiles, it also on occasion published a "thinly veiled critique of Surrealism," for example in the Americana Fantastica issue (1943). This was "a quiet declaration of independence."[22] Parker Tyler's editorial tried to enforce a distinction between the surrealist fantastic and "Americana fantastica," claiming that "the untutored, the oppressed, the insane, the anarchic and the amateur" remained immune to the strangling of the imagination by surrealism's imposed methodologies.[23] Tyler is, however, only repeating surrealism's long-standing interest in outsider and primitive art and writing. The difference, it has been claimed, is that *View* "relocated the 'primitive' to an urban setting" and attended to the "specificities of urban subcultures and their vernacular."[24] The surrealists (whose radical challenge to bourgeois values in Europe had been rooted to some extent in the subversion of the everyday, the poeticization of the city and the street, and the revaluing of overlooked popular cultures), now transplanted to an unfamiliar setting, lacked fluency in the new vernacular and looked instead to the indigenous and pre-Columbian cultures of the New World. Although it is true that *VVV* and *Dyn* both prominently feature native America, the division is not clear-cut. A New York–based notion of a vernacular urban culture can, for instance, be blind to the kind of street imagery in Manuel Alvarez Bravo's photographs. Those reproduced in *Minotaure* include the assassinated worker (*After the Riot* [also known as *Striking Worker Murdered*]) and the coffinmaker's shop—both commented on by Breton in "Souvenir du Mexique." It is interesting that those chosen for reproduction in *Dyn,* such as *Fable of the Dog and the Cloud* (see this volume, p. 56, fig. 15), are more ambivalent in their setting and have more explicit poetic and symbolic associations, as Donna Conwell has

argued in her essay, "The Photographic Aesthetic of *Dyn* (this volume, p. 35–62)."

*Dyn* gained in strength from issue to issue. Its first number received a lukewarm review in *Partisan Review:* it is "'progressive,' uneven in content and the result is diffuse-ness," despite Paalen's "energy and intelligence." However, the review's author had little understanding of the eclectic nature of surrealist journals, finding, for example, *VVV* merely "marginalia," "composed of fine bits of odds and ends."[25] The juxtaposition of modern painting, poetry, ethnography, and archaeology in *Dyn,* though, has less to do with the violent and radical challenge to self-centered Western civilization epitomized by a journal like Georges Bataille's *Documents* (1929–30) than with an encompassing hope "that art can reunite us with our prehistoric past" as well as "prefigure what might be."[26] *Dyn*'s coverage of ethnographic material is on a completely different scale from that of *VVV,* and its Amerindian double issue (nos. 4–5) published "a more impressive record of recent and important archaeological discoveries than have ever before been gathered between the covers of one review" (fig. 3).[27] Articles on newly discovered codices by the eminent authority Alfonso Caso and on Tlatilco by Miguel Covarrubias are major scholarly contributions; Covarrubias reports in the latter on the specially convened archaeological congress that agreed, reluctantly, on the great antiquity of the so-called Olmec civilization.[28] The sixth (and final) issue of *Dyn* includes the article "La Venta—Colossal Heads and Jaguar Gods," Covarrubias's firsthand account of the recent discoveries at the Olmec site. In the same issue, the final fragment from Paalen's "Paysage totémique" was published, together with a dazzling survey of contemporary art.

Paalen's drive and ambition were to bring together in *Dyn* a rich mix of poetry, art, ethnography, aesthetics, and archaeology, thus forging links between the ancient, the primitive, and the modern in a wholly original way.

## Notes

**1.** Wolfgang Paalen, Alice Rahon, and Eva Sulzer reached Mexico in September 1939, having left Europe in May to travel to the Pacific Northwest. Gordon Onslow Ford and his wife, Jacqueline Johnson, arrived in the autumn of 1941; Benjamin Péret and Remedios Varo in December 1941. Leonora Carrington reached New York in 1941 and moved to Mexico early in 1943. André Breton, André Masson, Max Ernst, and Yves Tanguy were all in New York by 1941.

**2.** Paul Goodman, "The Big Little Magazines," review of *The Little Magazine,* by Frederick Hoffman, Charles Allen, and Carolyn Ulrich, *View* 7, no. 1 (1946): 48–49. Goodman argued that the authors had totally misunderstood the nature of "little magazines" and had attempted, amusingly, to classify them as "Poetry, Leftist, Regional, Experimental, Critical and Eclectic."

**3.** Letter from Benjamin Péret to Guatemalan poet Miguel Angel Asturias, 25 January 1942, in which Péret, writing from Mexico, solicited contributions to the new journal *VVV* on behalf of André Breton. Benjamin Péret, *Oeuvres Complètes,* vol. 7 (Paris: J. Corti, 1995), 363. The new review was to appear in English, French, and Spanish. Unless otherwise noted, all translations are mine.

**4.** Nicolas Calas, "Review of Reviews," *VVV,* no. 1 (1942): 68. *Dyn* probably appeared too late to be included, as it and *VVV* came out for the first time almost simultaneously.

**5.** Letter from César Moro to Emilio Adolfo Westphalen, 2 May 1941 (fragment), Emilio Adolfo Westphalen papers regarding surrealism in Latin America (200.1.M.21), Getty Research Institute, Los Angeles; hereafter Westphalen papers.

**6.** Letter from Moro to Westphalen, 2 October 1941 (fragment), Westphalen papers.

**7.** Letter from Moro to Westphalen, 25 November 1941 (fragment), Westphalen papers.

**8.** Wolfgang Paalen in *View* 1, nos. 7–8 (1941): 5. Following Calas's interview with Breton, a page headed "Cords and Concord" assembled comments from assorted current and former surrealists, including this by Paalen, as well as from Duchamp, Suzanne Césaire, and Roger Caillois.

**9.** Wolfgang Paalen, "The Dialectical Gospel," *Dyn,* no. 2 (1942): 54.

**10.** "Inquiry on Dialectic Materialism," *Dyn,* no. 2 (1942): 49.

**11.** Paalen, "Dialectical Gospel," 59.

**12.** *VVV,* no. 1 (1942).

**13.** *Dyn,* no. 1 (1942).

**14.** Martica Sawin, *Surrealism in Exile and the Beginning of the*

DYN

4 - 5

AMERINDIAN
NUMBER

**Fig. 3.**   **Cover of the Amerindian issue of *Dyn*, nos. 4–5 (1943)**
Design by James Speck (Kwakwa̱ka̱'wakw [Kwakiutl],
active 1940s)

*New York School* (Cambridge: MIT Press, 1995), 272. Serge Guilbaut, in *How New York Stole the Idea of Modern Art: Abstract Expressionism, Freedom, and the Cold War* (Chicago: Univ. of Chicago Press, 1983), 79–80, highlights the importance of Robert Motherwell's article "The Modern Painter's World," which appeared in *Dyn* 6 (1944): 9–14, but does not mention Paalen himself.

**15.** See *Minotaure,* nos. 12–13 (1939): 16–17. In "Des tendences les plus récentes de la peinture surréaliste," Breton names Paalen as one of the most important of the new generation of painters belonging to the surrealist movement, whose work, together with that of Oscar Dominguez, marked a clear return to automatism (16). Breton mentions Paalen's "fumage" and describes his technique of spreading different colored inks on a sheet of white paper, then rapidly turning the paper and blowing on it to disperse the colors. In this issue of *Minotaure,* Paalen's *Totemic Passage of My Childhood* (1937) was reproduced in color, and in the same issue, a review by Herbert Read of Paalen's exhibition at the Galerie Guggenheim Jeune in London comments on the invention of a new world of forms "human or divine, vital or crystalline," free of conventions, of a pictorial universe open to a space that is cosmic as well as "phantasmagoric." In "Des tendences les plus récentes de la peinture surréaliste," Breton associates Albert Einstein's space-time concepts with the preoccupations of Roberto Matta and Gordon Onslow Ford—both of whom were to have close connections with Paalen in Mexico.

**16.** A translation of this essay can be found in Dawn Ades, ed., *The Colour of My Dreams: The Surrealist Revolution in Art* (Vancouver: Vancouver Art Gallery, 2011), 221–23.

**17.** Louise Tythacott, *Surrealism and the Exotic* (London: Routledge, 2003), 169.

**18.** Gordon Onslow Ford, "Paalen and Dyn," in Christian Kloyber, ed., *Wolfgang Paalen's DYN: The Complete Reprint* (Vienna: Springer, 2000), xiii.

**19.** Hare was Breton's third choice. Breton had previously approached Robert Motherwell and Charles Henri Ford, both of whom rejected his invitation. See Joanna Pawlik, "Negotiating Surrealism: Postwar American Avant-Gardes after Breton" (Ph.D. diss., University of Sussex, 2008), 41.

**20.** Sawin, *Surrealism in Exile,* 191.

**21.** Quoted in Fabienne Bradu, *Benjamin Péret y México* (Mexico City: Aldus, 1998), 35. Péret's extract appeared nonetheless in *View* 3, no. 2 (1943). He was Breton's most loyal supporter, but this did not stop him from seeing, occasionally, Paalen and Rahon in Mexico City. Moro helped him collect material for his anthology; scholarly as this is, Péret insisted that what he valued was the poetic quality of the myths and legends he collected from all over the Americas. This is similar to Moro's approach to the stones of Cuzco in his text "Coricancha" (*Dyn,* nos. 4–5), but increasingly the emphasis in *Dyn* was on serious scholarly investigation of the lost or marginalized civilizations of the Americas. *View* belatedly followed suit with its Tropical Americana issue (1945).

**22.** Dickran Tashjian, *A Boatload of Madmen: Surrealism and the American Avant-Garde* (New York: Thames & Hudson, 2001), 255.

**23.** Parker Tyler, "Americana Fantastica," *View* 2, no. 4 (1943).

**24.** Pawlik, "Negotiating Surrealism," 59.

**25.** Harvey Breit, "With the Little Mags," *Partisan Review* 9, no. 4 (1942): 443.

**26.** *Dyn,* nos. 4–5 (1943): n.p.

**27.** *Dyn,* nos. 4–5 (1943): n.p.

**28.** Miguel Covarrubias, "Tlatilco: Archaic Mexican Art and Culture," *Dyn,* nos. 4–5 (1943): 40–46; the conference was the 2nd Round Table Discussion of Anthropological Problems, held in Tuxtla, Chiapas, in 1942.

# The Painting Aesthetic of *Dyn*

**ANNETTE LEDDY**

*Dyn,* created seventy years ago in Mexico by a group of European and Latin American émigrés, was arguably the most original art journal of its day. Remarkably, it remains original, not only on first perusal but also on deeper immersion. Wolfgang Paalen's paintings on color plates are the first to attract our attention and curiosity, as they are both visually arresting and not typical of any familiar school, being neither precisely surrealist nor biomorphic. Continuing to turn pages, one is soon intrigued by the mix of pre-Columbian art, photography, and modern painting—and, within the latter, the unorthodox mix of artists. One senses a high level of coherence in the journal's visual argument, though what is being argued is not immediately graspable.

The impression of coherence turns out to be an effect of the relatively few artists whose work appears in the journal, especially in the first issue. There is Paalen; Paalen's assistant editor, Edward Renouf; Paalen's wife, Alice Rahon; and Paalen's former lover, Eva Sulzer. John Dawson, Jean Caroux, and Charles Givors are pseudonyms

of Paalen's, and their works seem to be cruder renditions of similar themes, or to represent the paintings Paalen made before *Dyn*. Some may have been included as examples of the incorrect direction for art.[1] According to Renouf, however, Paalen—desperate to lead a movement to rival André Breton's—artificially inflated the number of artists determined to bid farewell to surrealism.[2]

Knowing this slight fraudulence does not, strangely, diminish our fascination with the journal; rather, it adjusts our relationship to it. *Dyn* is something between a magazine and an artist's book, and something more like a blog than an edited magazine. Readers are not only witness to but somewhat complicit in Paalen's strategy of creating a "school" comprising mainly himself; the strategy of "including" artists from New York, as though Paalen were recognizing them when it is he who wants to be recognized by them; the project of reinventing a mid-twentieth-century art history; and the still-resonant effort to make art located at the interstices of science and anthropology.

Of the core group of *Dyn*'s émigré artists, which includes English painter Gordon Onslow Ford, all but Renouf had come to Mexico seeking refuge from the war, the outcome of which was still in doubt in 1942. It was known, however, that both Allied and Axis powers were close to developing a weapon forceful enough to destroy the world. This historical moment partly explains Paalen's and Onslow Ford's interest in physics and also infuses *Dyn* with an urgency amplified by the work of César Moro, another member of the core editorial group, whose poems in *Dyn* are imbued with a sense of an unprecedented world crisis.

At the same time, *Dyn*'s accounts of the core group's retreat from Europe (and detour, for some, into British Columbia), along with its descriptions of side trips into the Mesoamerican jungle in search of pre-Columbian treasures (often illustrated with photographs of the artists next to pre-Columbian monuments), lend the journal a family-album kind of charm. Onslow Ford, who wrote that he "could think of no artist who benefitted from the war," withdrew into a Stone Age Tarascan village[3] with his wife, Jacqueline Johnson, *Dyn* writer and editor. This condition of being immersed in the past while still attuned to the potential disaster of the future—the *Dyn* variation of dancing on the edge of the abyss—is another of the journal's seductions.

The extent of the group's immersion in the pre-Columbian is certainly impressive. It emerges especially in the Amerindian issue (*Dyn,* nos. 4–5), of which Miguel Covarrubias essentially serves as guest editor. The hunting, hoarding, photographing, sketching, painting, and theorizing that these ancient treasures elicited, as well as the artists' collective eagerness to inhabit a pre-Columbian consciousness—however projective such a concept may have been—are part and parcel of their prescient art. Indeed, the most exciting aspect of the journal is the way that reshuffling and comparing *Dyn*'s images—from the documentary archaeological photographs, to the glyphs that mark the beginnings and endings of articles, to the fine art photography and oil painting—reveals the process through which most of the paintings by the core group of artists evolved from designs on pre-Columbian sculpture, codices, pots, blankets, and petroglyphs that cryptically and economically portray animals, kings, and landscapes.

In his *Dyn* essays, Paalen articulates an aesthetic theory that enunciates in 1942 what will be key beliefs of anti-Stalinist, leftist art critics for the subsequent fifty years.[4] He is against realism, especially the ideologically illustrative or "official" sort; he is against irrationalism, specifically the surrealist elevation of unprocessed detritus from dreams; and he is against the concept of art as "superstructure," that is, as an activity inessential to human existence. Paalen's relatively unique, if elusive, solution is an art that is revolutionary because it "prefigures the possible,"

expressing the potential of "a new order of things" without reference to what already is. Lamenting the loss of art's role in ancient cultures, where it was intertwined with science and religion, he cautions that unless art and science become complementary activities, civilization is doomed.

Paalen's argument develops through all six issues of *Dyn,* and even those artworks that don't specifically illustrate Paalen's essays are meant to demonstrate an art that has evolved beyond cubism and surrealism, one in which art and science are intertwined. The paintings lend the essays greater interest than they might otherwise have today, when the concept of science and art sharing leadership of Western culture is even more of an apparent fantasy than it was in 1942. Moreover, Paalen's disputes with Breton, to whom the above-summarized arguments about politics and art are largely directed, seem mostly hairsplitting upon closer examination. Of supreme importance at the time, the arguments hold only historical interest today. They fall away; the paintings remain.

The painters Paalen, Renouf, Rahon, Onslow Ford, and Carlos Mérida each in his or her own way struggled to find points of connection between pre-Columbian imagery and another kind of imagery that would merge with the pre-Columbian in a visual abstraction. For Paalen and Onslow Ford, as for a number of their cubist and surrealist predecessors, that complementary imagery came from science, though they sought a new way to implement the discoveries of wave mechanics and quantum physics.[5] Renouf, in contrast, incorporated metaphysical psychology, while Rahon found a complementary imagery in geology. Mérida, who was not part of *Dyn*'s editorial group but connected socially to its members and a high-profile artist in the journal, had recourse to archaeology.

Paalen's oscillator paintings, arguably the peak fulfillment of the collective *Dyn* quest, seek specifically to join pre-Columbian art with visualizations of descriptions from 1930s physics texts on wave mechanics and other processes. This visual joining of past and present and art and science was key to Paalen's project of restoring art's centrality to modern life. Though no scientific illustrations appear in *Dyn,* Paalen's essays refer to Louis de Broglie, Erwin Schrödinger, and other physicists whose work inspired him, and Onslow Ford attested that Paalen was trying to paint the magnificent hidden world physics had revealed.[6] We may speculate that Paalen derived inspiration from the rudimentary diagrams illustrating Schrödinger's *Four Lectures on Wave Mechanics* (fig. 1), a lecture series (later compiled into a book) that Paalen is thought to have attended. Perhaps more evocative were descriptive passages such as the following from de Broglie's *Matière et lumière* (1937; Matter and light), whose title Paalen gave to one of his own paintings:

> We have seen how a wave advances in a region where
> there is nothing to interfere with its propagation.
> But conditions are different when a wave meets with
> an obstacle in the course of its journey; for example,
> if it meets with a surface that stops or reflects it, or
> again if it has to pass through an aperture in a screen,
> or if it meets particles of matter which diffract it.
> In such a case the wave will be deformed and turned
> back on itself, with the result that instead of a simple
> wave we shall have a multiplicity of simple, but
> superimposed waves.... If there is an additive effect
> as between the various simple waves, or if they
> are in a phase, as it is called, then the resulting vibra-
> tion will be one of great intensity.[7]

We might regard *Pandynamic Figure,* the first painting and first image in the first issue of *Dyn,* as an imagining of superimposed waves in a vibration of great intensity (fig. 2).[8] The oscillating forms suggest both water and light. They

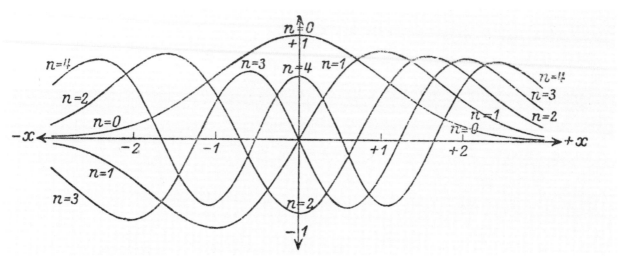

**Fig. 1.**

**Erwin Schrödinger
(Austrian, 1887–1961)**
Diagram
From *Four Lectures on Wave Mechanics* (London: Blackie & Son, 1928), 39

could be swirling reflections of light in a pool or reflections of light in the sky. One experiences the vibrations as a compulsory movement inside the painting, no matter where his or her eye enters the painting. If a viewer enters, for example, at the point in the upper-left-hand side that looks like an abstracted blue eye, he or she follows a path to the next wave, to another eye (like the eye of a tornado), and from that one to the next, until all of the waves and eyes are followed back to the blue eye. The viewing cycle then begins again.

At the same time, the eyes reflect one's own eye that is drawn into the act of looking, and they incorporate elements from Northwest American Indian totemic drawings or carvings in which several pairs of eyes are embedded in an overall design connecting various members of a clan with symbols that define them. This kind of source emerges more explicitly through a comparison between a page marker derived from a Northwest American Indian totem carving (fig. 3) and a painting by John Dawson titled *What the Sailor Will Say* (fig. 4). The oscillating waves in the upper center of the painting present two eye-like forms, black surrounded by blue, that recall the embedded eyes in the totemic page marker.

Paalen's totemic figure, quite submerged in abstract waves in the paintings from the first two issues of *Dyn,*

WOLFGANG PAALEN.

*Figure pandynamique,* 1940
*oil, 51 x 38 inches.*

**Fig. 2.**    **Wolfgang Paalen (Austrian, 1905–59)**
*Pandynamic Figure,* 1940
From *Dyn,* no. 1 (1942): facing p. 1

begins to emerge in the third issue, in *Space Person* (fig. 5). This painting's source may well be the small stone figure that illustrates Paalen's essay in *Dyn,* nos. 4–5 (fig. 6). Found in the Bay of Bella-Bella, British Columbia, the stone figure is compressed and focused on the navel, with spirals around the eyes and mouth. The preliminary drawing for *Space Person* may have been one of the ink drawings in the first issue of *Dyn* (fig. 7), which seems also to refer to the stone figure. The figure in the drawing has limbs that spiral toward the viewer, showing a tighter movement with greater velocity than the painting that is its successor in *Dyn,* no. 3 (cf. fig. 5).

In that painting, the waves form a crude figure, baby-like with a chubby face and limbs, bug eyes, a grimace, and stubs for hands and legs. At the same time, the figure is nearly illusory, for it is like a face in a cloud or in the moon; we see the waves themselves as more primary, important, and eternal; the figure itself is fleeting, expressing the insignificance of humanity in the cosmos. The colors in this work seem to echo the John Dawson painting of *Dyn,* no. 1 (see fig. 4). *Space Person* retains those outlines (recalling the rings around the eyes of the Northwest

American Indian totemic figures) but fuses them with the liquid, oil, and water blues of *Pandynamic Figure*. The palette covers a wider range of colors and is almost childlike in its yellow, red, and blue near-rainbow array.

It seems quite likely that the stone figure from which the painting developed is also the source of the Dyn sign, the journal's key emblem (fig. 8). The head of the stone figure, perfectly round like the earth, is carved with three sets of rings, for each eye and the mouth, lines that could be easily abstracted to suggest the parabolas evident on the Dyn sign (fig. 9).[9] Like any effective emblem, the Dyn sign has multiple possible references, but it is primarily a face that is also a planet, a planet penetrated by a spaceship that is also a boomerang. It evokes the image of the atom, too, popularized in magazines of the period and found on a page from *National Geographic* in Paalen's papers.[10]

The final occurrence of Paalen's totem figures in *Dyn* is in *The First People from Space* (1941–44), a triptych in *Dyn,* no. 6. Here a face that is adult, not baby-like, emerges from the oscillating waves with the Dyn sign forming the eyes and mouth. The figure seems to swirl in the waves of light and matter, his mouth pointing downward in fear or

**Fig. 3.**     **Graphic design
based on Northwest American Indian
totem carving**
From *Dyn,* no. 2 (1942): 42

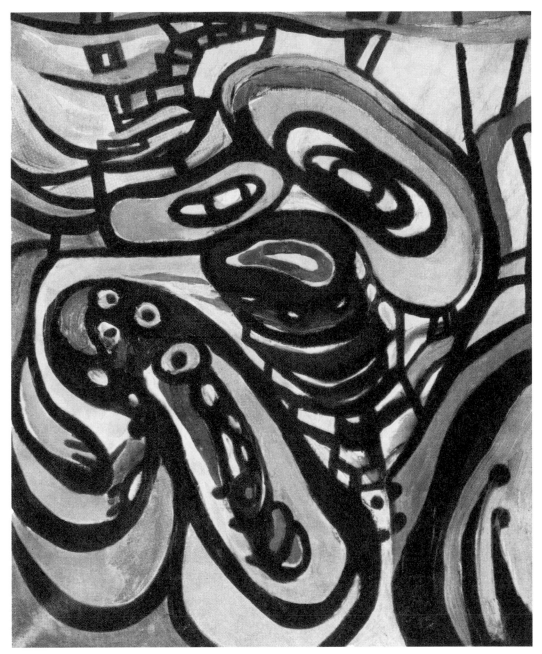

**Fig. 4.**                              **John Dawson [Wolfgang Paalen] (Austrian, 1905–59)**
*What the Sailor Will Say*, 1942
From *Dyn*, no. 1 (1942): 23

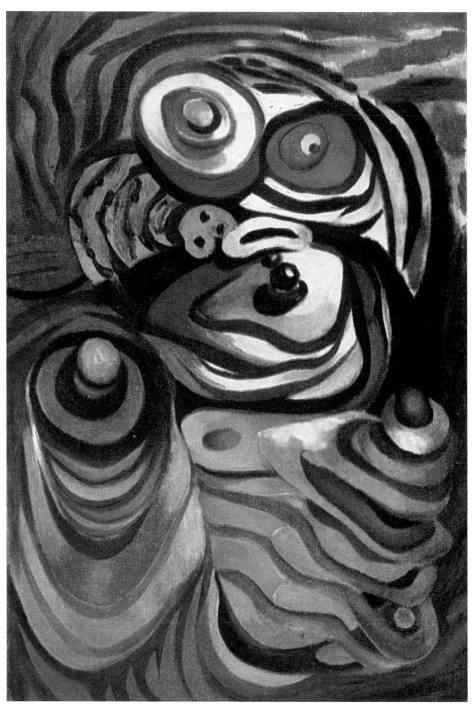

**Fig. 5.**                    **Wolfgang Paalen (Austrian, 1905–59)**
*Space Person*, 1941
From *Dyn*, no. 3 (1942): after p. 12

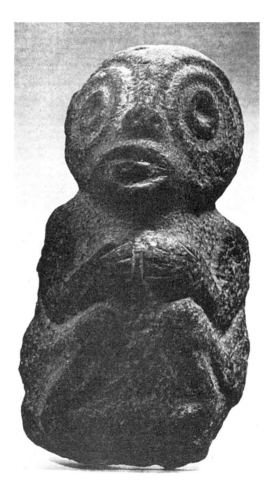

**Fig. 6.**  **Small stone figure
found in the Bay of Bella-Bella,
British Columbia**
From *Dyn*, nos. 4–5 (1943): 13

**Fig. 7.**  **Untitled ink drawing**
From *Dyn*, no. 1 (1942): 31

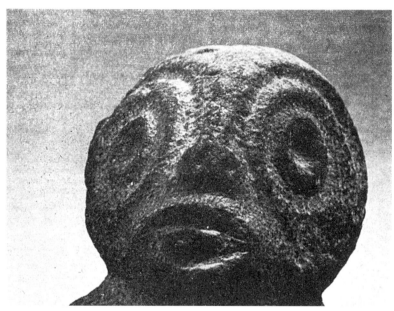

Fig. 8.  **Small stone figure found in the Bay of Bella-Bella,
British Columbia (detail of fig. 6)**
From Dyn, nos. 4–5 (1943): 13

confusion. These first beings from space indicate the direction Paalen will take in creating a series of paintings about the Cosmogons, cosmic totemic figures that offer hope and show the right direction for Earth.[11]

The *Dyn* reader of 1942 was clearly meant to see these paintings as not only a "new image" but also a move away from a stale Bretonian surrealism with its Freudian sources. The paintings were extensively discussed in Roberto Matta's New York workshops, where the focus was on developing a new concept of space and a more abstract and multivalent imagery than had characterized the first and second stages of surrealism. Paalen's paintings such as *Space Unbound* (1941) were the first to become fields of sheer energy, and their engagement of the viewer in a self-reflective act of looking was seen as the alternative to Matta's "fourth wall" concept of space.[12]

Robert Motherwell brought the first issue of *Dyn* to the Matta workshop, where he reportedly expounded at length on Paalen's theories, which he had been exposed to for an intense six months during a visit to Mexico City in 1941.[13] He had also translated into English Paalen's essay "The New Image" in *Dyn,* no. 1. Motherwell remained a conduit

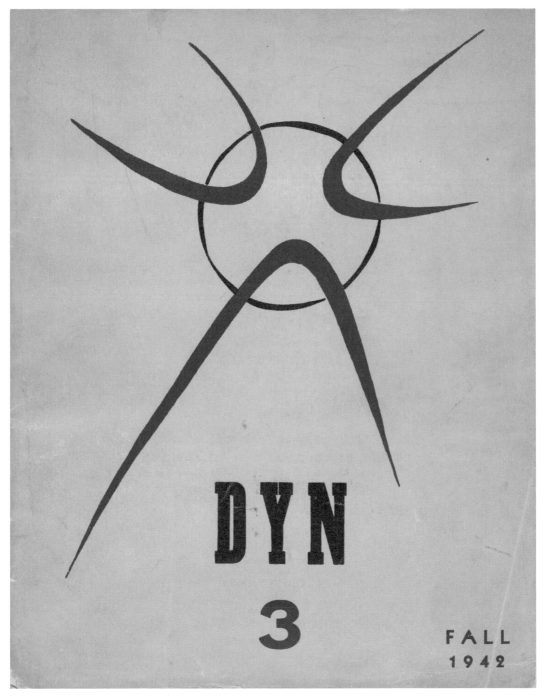

**Fig. 9.**  **The Dyn sign**
From cover of *Dyn*, no. 3 (1942)

between New York artists and the *Dyn* group, though Paalen and Rahon also made frequent trips between the two cities—doubtlessly necessary if they were to take full advantage of *Dyn*'s success as a showcase for their work.

Another delegate from the New York art scene was core *Dyn* group member Edward Renouf, a young artist who had come to study with Paalen on the advice of gallerist Julian Levy. Renouf acted as assistant editor and also created drawings and paintings that echo conventions of ancient Mexican emblems, such as those found in a one-page piece by Jorge Enciso in *Dyn*'s Amerindian issue (nos. 4–5). Titled "Seals of the Ancient Mexicans" (p. 54), Enciso's piece shows designs from wooden seals that "represent stylizations of human figures, animals, plants and patterns." The dual nature of these images—in which, for example, a series of hands may also be plants, or one animal may be growing out of the tail of another (fig. 10)—surfaces in Renouf's drawings as two-sided, hybrid figures (fig. 11).

Renouf's first *Dyn* painting appears in *Dyn*, no. 2. Titled *Hell Bird* (fig. 12), the painting portrays a bird with the webbed wings of a bat and the sharp beak of an eagle.

**Fig. 10.**  **Jorge Enciso**
**(Mexican, 1879-1969)**
Illustration of hummingbird (detail)
From *Dyn*, nos. 4–5 (1943): 54

**Fig. 11.**  **Edward Renouf**
**(American, 1906-99)**
*Drawing*
From *Dyn*, no. 1 (1942): 28

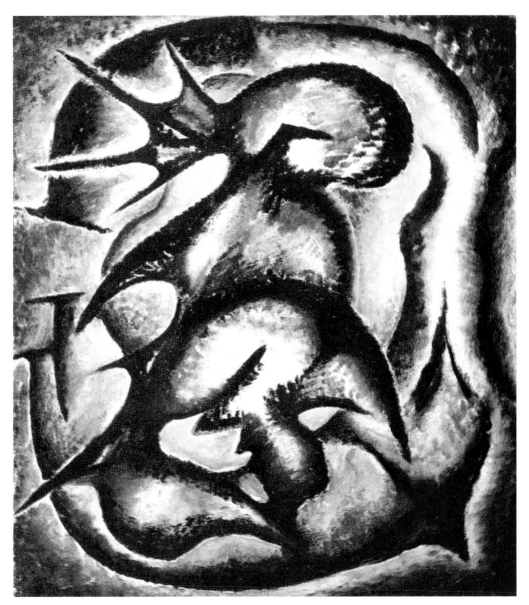

**Fig. 12.**                                    **Edward Renouf**
**(American, 1906–99)**
*Hell Bird,* 1942
From *Dyn,* no. 2 (1942): 9

Upon closer examination, the single bird appears to be multiple birds inside one another; it is impossible to see where one bird ends and another begins. Light from an unseen source reflects off the black, shiny feathers of the birds, which are threatening creatures from a nightmare. *Hell Bird* may refer to Max Beckman's *Bird's Hell* (1938) an allegory of Nazi Germany, where the Nazi figures have talons for hands, partly in reference to the Nazis' selection of the eagle as their symbol. Renouf's painting is a more compressed, internal image than Beckman's. The interlocking birds are contained within a rough profile shape, and the birds feed on an animal-human shape lying prone at the bottom of the painting. The violent predator-prey relationship is thus contained within the psyche of the culture that the profile represents.

This theme continues in Renouf's brush drawings on pages 11 to 13, which also focus on the demonic, as the nonsense rhymes accompanying them make clear: "Demons look into mirrors and see angels, and angels see demons, and I see you" (p. 13). These abstract figures, with their pointed talons and twisted spines, look like the vertebrates of *Dyn,* no. 1, yet they are a bit more like trees that are burned or without leaves. They could also be studies for *Hell Bird*. Prominently dated 1942, they must also refer to that critical year of the war when the conflict between Allied and Axis powers was held in balance.

Like Renouf, Alice Rahon draws on pre-Columbian incisions, especially petroglyphs, in her work.[14] The petroglyphs from the Amerindian issue of *Dyn* correlate most obviously with her painting in the first issue. Carved into

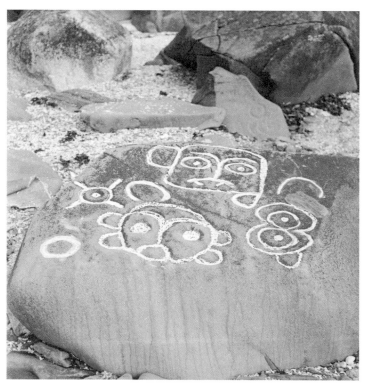

**Fig. 13.**             **Eva Sulzer (Swiss, 1902–90)**
Petroglyphs in Wrangell, Alaska, 1939, photographic print from
original negative, 6.5 x 6 cm (2 ½ × 2 ⅜ in.)
Los Angeles, Getty Research Institute, 2012.M.4

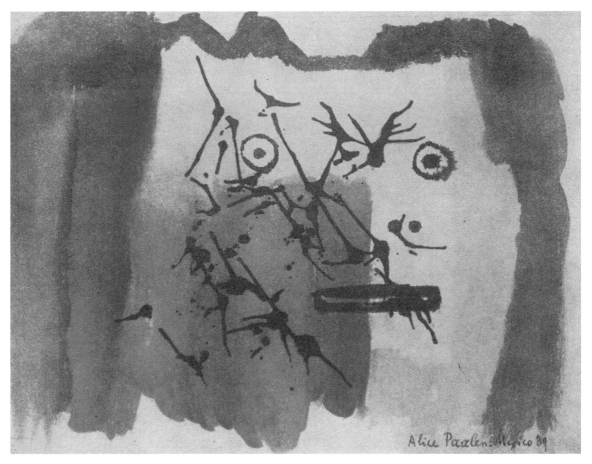

**Fig. 14.**                                              **Alice Rahon (French, 1904–87)**
*Poem-Painting*, 1939
From *Dyn*, no. 1 (1942): 35

**Fig. 15.**

**Alice Rahon (French, 1904–87)**
*Meeting of Rivers*, 1942
From *Dyn*, no. 3 (1942): after p. 4

rocks centuries before, they reflect the ravages of wind, sun, and water and remain enigmatic signs that invite and resist interpretation (fig. 13). *Poem-Painting* is a rather typical surrealist presentation of an abstract landscape as a face (fig. 14). Perhaps too explicit for the *Dyn* aesthetic, it shows an anthropomorphic impulse in the sad and puzzled expression on the face of Earth, rather than grasping nature's "universal procedures."

Rahon's paintings in the second and third issues of *Dyn* pursue the same theme as *Poem-Painting*—that of intelligible signs in a timeworn geography—but in a more abstract manner. *Moraines* (1942) depicts a geological phenomenon of intersection and erosive pressure. Formed by the movement of a glacier, moraines are ice and rock and debris, the earth's marking of time on itself. Like *Meeting of Rivers* in *Dyn*'s third issue (fig. 15), *Moraines* presents an aerial view of an earth that is scarred or scraped, with formations that nearly compose an intelligible figure or image but remain abstract. The scars' beauty lies in the textures, tones, and lines, randomly incised but reflecting toil. A possible source for these works is Eva Sulzer's photograph *Childhood* in *Dyn*, no. 3, which shows a stone mountain eroded in a way that hints at the sculpture of a human form but refers generally to the surrealist interest in geological source material.[15] *Meeting of Rivers* also suggests the skeleton of a vertebrate, in another merging of plant and animal that draws on paleontology.

Rahon's creatures in the sixth issue of *Dyn* are called *Crystals of Space* (fig. 16). Brush drawings of white ink on black paper, they have a kinship with Paalen's all-knowing "messengers." Made of light, the creatures combine the decorative figures of ancient cultures with the cartoon-like imaginings of robots or mechanical toys. They are hybrid: part human, part animal, part machine, part light. They are full of energy, in some cases seeming to dance, in others seeming to fly. They are technical, like X-rays of figures and scenes, and also suggest weaving, sewing, doilies, and embroidery. Like several of the paintings in this issue, the creatures point to outer space and invisible worlds coexisting with our own. At the same time, they recall a sketch Rahon did in British Columbia, published in *Dyn,* no. 1, of totem poles at the Skeena River. Like the space creatures, the totem poles cluster, lean, and look.

Beginning with *Dyn,* no. 2, the work of Guatemalan painter Carlos Mérida assumes a significant role in the journal. Known for his elaborations of folk art figures and themes from various Latin American cultures and periods, Mérida had been influenced by László Moholy-Nagy's book *Vision in Motion* in the late 1930s and was moving toward a more abstract painting style that retained references to indigenous and ancient Mexican cultures through the use of archaeology.[16] The clearest expression of this practice is his placement of drawings of the giant Olmec heads from La Venta in an abstract landscape of color blotches suggesting rain and sun of the ages in *Dyn,* no. 6 (before p. 13). Mérida's painting in *Dyn,* no. 2, refers to cave paintings. His three nearly identical elephants look like the red line drawings found in ancient caves; they contain shadow forms, possibly human, suggesting evolution, or perhaps the dual evolutions of art and the species.

Like Rahon, who was a close friend and colleague and whose work he reviewed, Mérida refers to petroglyphs in *A Little Window toward the Sea* (1942). The shapes of his figures, however, suggest the small clay figurines from Tlatilco that Covarrubias discusses in the Amerindian issue of *Dyn* (fig. 17) and that appear again in *All in Rose* (fig. 18), where they wander in an abstract red landscape. The red could refer to earthen clay, or caves, or simply to paint as an artist's material through the ages. It also evokes spilled blood in this pivotal year of World War II. The sharp instruments in the painting's foreground resemble the stylized images of claws from Tlatilco and Chilkat blankets (fig. 19) while simultaneously suggesting weaponry.

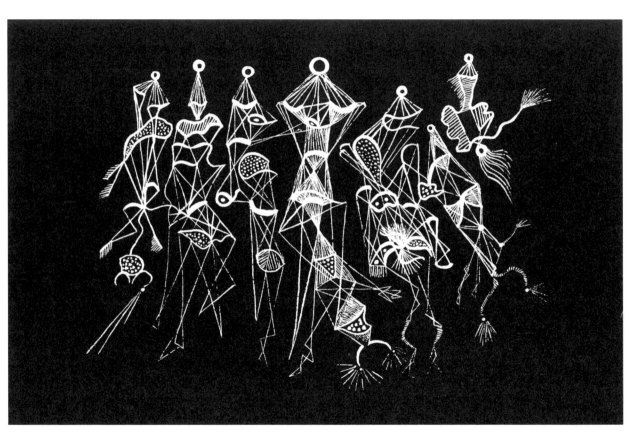

**Fig. 16.**  **Alice Rahon (French, 1904–87)**
*Crystals of Space*, 1943
From *Dyn*, no. 6 (1944): after p. 20

Gordon Onslow Ford reportedly moved to Mexico in order to support Paalen in the *Dyn* endeavor, and letters show that he and his wife, Jacqueline Johnson, were involved financially and editorially in addition to being involved in ongoing discussions about artwork and ideological concerns simply by virtue of being close friends of Paalen's.[17] Settled for six years in Eronguarícuaro, a village in Michoacán, and surrounded by the descendants of Tarascan craftspeople, the painter emulated the style of painting of the local artists, who knew nothing of European painting perspective. Onslow Ford's *The Marriage,* in the sixth issue of *Dyn,* reflects the painter's original focus within the *Dyn* group's shared interest in pre-Columbian artifacts (fig. 20).

Perhaps because of its proximity in *Dyn* to two cubist paintings, *The Marriage*'s antecedents are clear. Like the cubists, Onslow Ford was interested in the work of mathematician and physicist Henri Poincaré,[18] whose models of multidimensional space resemble the interlocking color panels that form the painting's background. Another layer of the painting employs the Tarascan "sunburst" pottery design to depict processes and ideas in a diagrammatic, yet oblique, manner (fig. 21). Between land and sky, a scientific experiment is taking place. Maybe it is the splitting of the atom. Energy for the experiment seems to be drawn from both the sun and a decanter, perhaps of water, and it moves into a rocket heading up into the sky where a cloud— of atomic rain?—gathers. Reminiscent of diagrams about condensation and evaporation, *The Marriage* also recalls the very stylized depictions of nature in pre-Columbian seals. The painting could be a depiction of Albert Einstein's theory of the equivalence of matter and energy as it would be explained by a pre-Columbian, and in that sense would be a "marriage" of heaven and earth. This painting, with its striking dynamic energy, thus represents a different way of combining a scientific vision with a vision of the ancient world. It may refer also to Gordon's marriage to Jacqueline and their unusually strong "chemistry."

Beyond this core group of *Dyn* painters are two outsiders whose work was frequently shown in *Dyn:* Henry Moore and Alexander Calder. Their introduction into the journal brings the work of the *Dyn* artists into a broader dialogue with European artists. In the *Dyn* context, Moore's work shows not only Greek as opposed to pre-Columbian Latin American source material but also a vision of science linked to the Greek Pythagorean music of the spheres (an alliance between the planets and musical tones), drawing thus on ancient rather than modern science. Calder's work, in contrast, seems easily assimilated into the *Dyn* aesthetic. When a drawing for a Calder mobile is placed adjacent to Paalen's *Totemic Landscape of My Childhood* (1937), it alters the way we see all the Calder mobiles. Suddenly they are totemic figures, cosmic parents who could toss the moon down on the ground as if it were a child's ball.

In *Dyn,* no. 6, Paalen makes the strategic gesture of featuring work by a group of emergent New York artists, including David Smith and Jackson Pollock. Four pages, 17 to 20, present black-and-white photographs of their sculpture and paintings similar to how they would be presented in *View* or *VVV.* In the pages of *Dyn,* however, their meaning shifts. Smith's *Sculpture* (1937) looks like a pre-Columbian abstracted landscape, as does a mobile by Xenia Cage titled *Scissor Fish* (1944). *The Balcony* (1944) by William Baziotes shows woodwork of a balcony in an abstraction that connects the shape to faces and bodies and even cave paintings, an association that probably would not have occurred outside of the *Dyn* context. The paintings by William Fett, one of which is titled *The Light Woman* (1944), have nothing in common with Rahon's creatures of light. They show monsters navigating a Matta-like geometric space. The Pollock has most in common with a Paalen painting. Titled *The Moon Woman Cuts the Circle* (1943), it

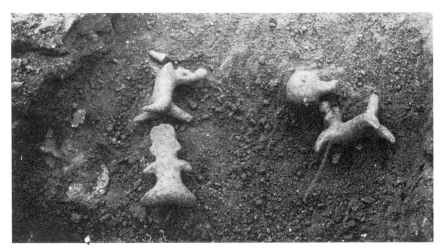

**Fig. 17.**     **Miguel Covarrubias (Mexican, 1904–57)**
Black-and-white photograph of clay figurines from Tlatilco, ca. 1940,
accompanying Covarrubias's text
"Tlatilco: Archaic Mexican Art and Culture"
From *Dyn,* nos. 4–5 (1943): 41

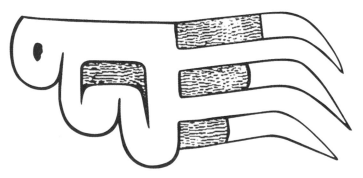

**Fig. 19.**     **Claw from a Chilkat blanket**
From Miguel Covarrubias,
"Tlatilco: Archaic Mexican Art and Culture,"
*Dyn,* nos. 4–5 (1943): 46

**Fig. 18.**                    **Carlos Mérida (Guatemalan, 1891–1985)**
*All in Rose,* 1943
From *Dyn,* no. 6 (1944): before p. 13

**Fig. 20.**                                      **Gordon Onslow Ford (British, 1912–2003)**
*The Marriage,* 1944, oil on canvas, 109.2 × 94 cm (43 × 37 in.)
Private collection

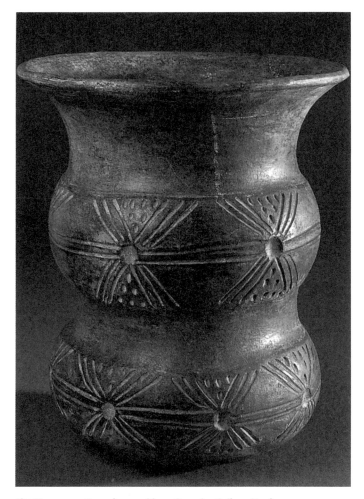

**Fig. 21.**      **Ceramic vessel from Capacha, Colima, Mexico
decorated with dots and
incised lines in a "sunburst pattern," ca. 1500–1000 BCE**
Photograph by Eduardo Williams

**Fig. 22.**　　　　　　　　　　**Wolfgang Paalen (Austrian, 1905–59)**
*The Space Ship,* 1937
From black-and-white photograph
Mexico City, Museo Franz Mayer

shows a mythical operation occurring in outer space, yet it seems less fully realized than Paalen's paintings on like themes. Only the Matta, printed on a color plate in this sixth issue, has a power comparable to the Onslow Ford or the Paalens. Called *Untitled* (1943), it refers to the war, with flying machines on fire.

Karl Nierendorf, the New York gallerist, visited the Paalen household in San Angel in 1945, after which he proposed to fund the next issue of *Dyn*. It was to feature a mix of New York and *Dyn* artists and to be on the theme of space, serving also as a brochure for a series of solo shows on Paalen's, Onslow Ford's, and others' works. This was a victory for both *Dyn* and Paalen, and in a letter from 1945 to Onslow Ford, Paalen acknowledges as much, asserting that "we and not the people in New York, are at the opening of the new road."[19]

In the same letter, Paalen discusses Matta, criticizing his work as too "satirical-analytical," by which he perhaps means that the specificity of the war references undermines Matta's aspirations to portray the cosmic.[20] He goes on to complain about Matta's characterization of him (Paalen) as "the first painter of the Atomic Age," worrying that this framing of his work would make him a "fool." After Paalen's death, however, his close friend Onslow Ford praised him for having "left us paintings prophetic of the space age."[21]

Paalen may have worried that such characterizations would confuse his work with the illustrations in lowbrow, rapidly proliferating science fiction magazines of the day. There is, in fact, some notable overlap of his work and popular culture productions about the atomic age. *The Space Ship* (fig. 22), a painting Paalen did while still in his surrealist stage, conjures the black-and-white postatomic Hollywood movies that warn about the hubris the bomb represents. Paalen's play "The Beam of the Balance"—never produced but given a private reading at Robert Motherwell's house in 1946—anticipates themes of "good alien" movies like *The Day the Earth Stood Still* (1951)

and was written in conjunction with his post-*Dyn* painting series *The Cosmogons*. In his preface to the play, Paalen explains the Cosmogons as "great cosmic forces." They share features of totemic figures from ancient cultures who want to deter Earth from a self-destructive path, especially as a result of "the recent atomic discoveries . . . which might tend to get out of control."[22]

Paalen's artwork and play, as well as the work of the other *Dyn* painters, who fused the pre-Columbian with psychology, geology, archaeology, and physics, anticipated a general cultural production of novels, movies, and television series about aliens based on figures from the mythology and religion of ancient cultures. Oddly, after fifty years of *Star Trek*, as we stand now on the other side of the space age, these paintings are anything but kitsch. Rather, they seem plausibly the work of artists living today seeking to connect popular space-age culture with deeper currents of global cultural history. While Matta's paintings remain brilliant examples of 1940s abstract surrealism, the work of the *Dyn* group seems, in contrast, uncannily fresh, brimming with possibilities for the future.

## Notes

**1.** The two abstract landscapes by Jean Caroux, for example, closely resemble an untitled Paalen work from 1938 that appears in Dieter Schrage, ed., *Wolfgang Paalen: Zwischen Surrealismus und Abstraktion* (Munich: Ritter Klagenfurt, 1993), 130. Both Carouxs in *Dyn* have the title *Paysage errant,* which we perhaps should read as "Paysage erronée" and an example of Paalen's wit. Unless otherwise noted, all translations in this essay are mine.

**2.** Gavin Parkinson cites Amy Winter's dissertation as evidence for this assertion in *Surrealism, Art and Modern Science: Relativity, Quantum Mechanics, Epistemology* (New Haven: Yale Univ. Press, 2008), 159.

**3.** Gordon Onslow Ford, *Toward a New Subject in Painting,* exh. cat. (San Francisco: The San Francisco Museum of Art, 1948), 16–17.

**4.** See Amy Winter, *Wolfgang Paalen: Artist and Theorist of the Avant-Garde* (Westport, Conn.: Praeger, 2003), 123–79, for a painstaking summary of Paalen's ideas and their various sources.

**5.** Parkinson, in *Surrealism, Art and Modern Science,* deftly explains the stages by which art integrated physics in the twentieth century.

**6.** Parkinson, *Surrealism, Art and Modern Science,* 157–68. Parkinson discusses the specific theories that inspired Paalen, who had a "surprisingly complete knowledge of the new physics." Amy Winter also acknowledges the influence of physics on Paalen—who, she reports, had been privately tutored in mathematics from an early age—but presents it as fused with pre-Columbian influences in his work; Winter, *Wolfgang Paalen,* 5.

**7.** Louis de Broglie, *Matter and Light* (New York: Norton, 1937), 26.

**8.** Parkinson, in *Surrealism, Art and Modern Science,* 167, offers a reading of this painting in terms of the scientific term *complementarity.*

**9.** Winter, *Wolfgang Paalen,* 124.

**10.** Wolfgang Paalen papers, Museo Franz Mayer, Mexico City.

**11.** Andreas Neufert, "Los pintores aún no han podido hacer hablar a la vieja esfinge . . ," in idem, ed., *Wolfgang Paalen: Retrospectiva,* exh. cat. (Mexico: Museo de Arte Contemporaneo Alvar y Carmen T. de Carrillo Gil, 1994), 47–83. Neufert discusses Paalen's totemic figures from the 1930s and their origins in Cycladic art.

**12.** Martica Sawin, "The Cycloptic Eye: Pataphysics and the Possible: Transformations of Surrealism," in Paul Schimmel, ed., *The Interpretive Link: Abstract Surrealism into Abstract Expressionism,* exh. cat. (Newport Beach, Calif.: Newport Harbor Art Museum, 1986), 37–41.

**13.** Winter, *Wolfgang Paalen,* 109.

**14.** Tere Arcq, "Alice Rahon: Tras los indicios de lo maravilloso," in *Alice Rahon: Una surrealista en México,* exh. cat. (Mexico City: Museo de Arte Moderno, 2009), 31–32. Arcq discusses Rahon's fascination with the prehistoric.

**15.** Such as demonstrated in a photo-illustrated article in *Minotaure,* no. 8 (1936): 20–21.

**16.** Alicia Sánchez Mejorada de Gil, "Su relación con las vanguardias," in *Homenaje nacional a Carlos Mérida (1891–1984): Americanismo y abstracción,* exh. cat. (Monterrey, Mexico: Museo de Monterrey, 1992), 87.

**17.** Martica Sawin, *Gordon Onslow Ford: Paintings and Works on Paper, 1939–1951,* exh. cat. (New York: Francis M. Naumann Fine Art, 2010), 15.

**18.** Sawin, *Gordon Onslow Ford,* 8. Poincaré's models, which had influenced the cubists, were photographed by Man Ray and published in *Cahiers d'art* in 1936. Onslow Ford, who was trained in math and science, including astronomy, was impressed with these images as a new way of moving beyond Euclidean geometry and expressing multi-layered space.

**19.** Letter from Paalen to Onslow Ford, 26 August 1945, Paalen Archiv Berlin.

**20.** Letter from Paalen to Onslow Ford, 26 August 1945.

**21.** Gordon Onslow Ford, "Paalen the Messenger," in *Hommage to Wolfgang Paalen, On the Occasion of an Exhibition of His Paintings at the Museo de Arte Moderno, Mexico,* exh. cat. (Mexico City: Museo de Arte Moderno, 1967).

**22.** Wolfgang Paalen, "Brief Outline of 'The Beam of the Balance,'" Paalen Archiv Berlin.

# The Photographic Aesthetic of *Dyn*

**DONNA CONWELL**

I do not hold the rights of documentary above others as
a way of understanding reality … nothing
can make me run back to this imaginary point zero of
observation, supposedly inserted like a
chaste sword between perception and interpretation.
No more can I establish an arbitrary solution of
continuity between the rising and falling of the curtain
on the visual presence, between what I see and
what I know.[1]
—Wolfgang Paalen, 1942

From 1942 to 1944, six issues of *Dyn,* the pioneering journal of art and literature, were distributed in London, Mexico City, and New York. Based in Mexico City, the journal's editor, Austrian painter and former surrealist Wolfgang Paalen, conceived of the journal as a forum for presenting "something new in art and thought."[2] He utilized *Dyn* as a platform to showcase his and his fellow contributors' ideas about the creative process, the significance of modern art, and the role of the artist. The journal included theoretical

texts; ethnographic articles on pre-Columbian cultures; and examples of advanced art in the fields of painting, sculpture, literature, and photography.

Paalen allocated a significant portion of the journal to showcasing innovative work by emerging and established photographers. The first photograph included in the inaugural issue of *Dyn* depicts the glacier-iced peaks of Ixtacihuatl, an extinct volcano and the third-highest mountain in Mexico, located seventy kilometers southeast of Mexico City (fig. 1). This is one of only three photographs featured in the first issue of *Dyn,* but photographic images acquired an increasingly important presence in the journal, with twenty-four photographs included in the final issue in 1944. The photographic sources and content are diverse, but most of them continue *Dyn*'s early focus on the Americas as subject. Throughout the six issues of the journal we see photographs of the ruins and artifacts of civilizations in Mexico, Peru, and the coast of British Columbia and southeast Alaska; the indigenous peoples of the Americas; and the urban and rural landscapes of the region. While these photographs are often presented as autonomous art photography, they frequently accompany—and operate in dialogue with—poems, essays, and scholarly articles.

Most of the photographers who contributed to *Dyn* were part of an international group of artists, scholars, and writers based in Mexico City who shared a deep fascination with the indigenous cultures and histories of the Americas. Some of them were professional photographers; others were amateurs. They recorded their discoveries and observations of the peoples, landscapes, and artifacts of the region through still photography, film, and illustration. Many of the photographers were avid collectors of pre-Columbian objects and indigenous folk art, and several were self-taught anthropologists and archaeologists, some of whom went on to have illustrious careers in those fields.

Photographers featured in *Dyn* include, most prominently, Paalen's companion and patron, Swiss heiress Eva Sulzer, whose images of the landscapes and artistic traditions of the First Nation peoples of the northwest coast of British Columbia and southeast Alaska are included in every issue of the journal; US-born photographer, dancer, and painter Rosa Rolando, who produced a large body of work documenting the indigenous peoples of Mexico, some of which is featured in *Dyn;* Mexican photographer Manuel Alvarez Bravo, who contributed enigmatic images of the activities and landscapes of the Mexican indigenous working class as well as photographs of pre-Columbian artifacts; and Alvarez Bravo's second wife, US-born photographer and future prominent scholar of pre-Columbian art Doris Heyden, whose mysterious images of Mexico's urban landscapes and inhabitants are also featured in *Dyn.*[3]

Photographs of pre-Columbian artifacts included in *Dyn* served as inspiration for the painters who contributed to the journal. But the role of photography in *Dyn* extends beyond its use as source material for a new painting style; it also represents an important aesthetic contribution in and of itself.

Determining an overall aesthetic for the photography in *Dyn* is complicated by the lack of archival documentation about Paalen's process of selecting photographs. It is unclear to what extent other contributors were involved in choosing images, particularly when the photographs were featured as part of essays, poems, and scholarly texts. Nevertheless, we can discern two key tendencies. The first is Paalen's interest in using photography to promote an anti-realist aesthetic that destabilizes the photographic truth of documentary realism and illustrates some of his core ideas about the role and significance of the image. He often does this by reframing anthropological and documentary photography (frequently through juxtapositions with text), but he also showcases photography that can be autonomously

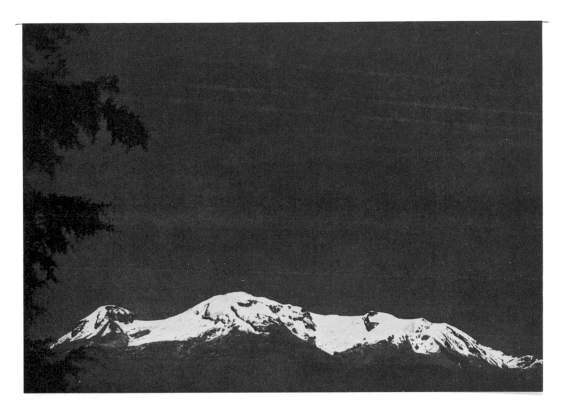

*l' Ixtaccihuatl*

*Photo H. B. Mexico.*

L'Ixtaccihuatl, nommée par les dieux, la femme endormie le visage tourné vers le soleil levant.

Toujours jeune géante, amante blanche de neige et d'aubes millénaires, miroir magique à l'échelle des plus grands rêves où l'homme s'est miré.

Ixtaccihuatl, Femme blanche, montagne sur le haut plateau, aux flancs de neige et de silence, porteuse d'horizons à venir.

44

**Fig. 1.**                           ***L'Ixtaccihuatl*, n.d.,**
**by Hugo Brehme (German, 1882–1954),**
**and untitled poem by Alice Rahon (French, 1904–87)**
From *Dyn*, no. 1 (1942): 44

described as antirealist. The second tendency is a marked rejection of the picturesque. The landscapes and peoples of the Americas are generally not presented as an idealized exotic other. As such, photography in *Dyn* unsettles the relationship between photography, anthropology, and the nation building prevalent in Latin America at that time.

## Antirealist Photography in *Dyn*

Paalen wrote extensively about painting but had relatively little to say about photography, despite the amount of space he allotted it in *Dyn*. Nevertheless, Paalen's scant comments on photography provide insight into his aesthetic approach to the medium. In the inaugural issue of *Dyn,* Paalen published his manifesto-like text "The New Image," in which he distinguishes between what he terms the "representative image" and the "prefigurative image." For Paalen, the former refers to the accepted and customary way of understanding and representing the world of a particular time, while the latter is revolutionary because it "does not represent what exists but *potentially* anticipates some feature of what will exist"[4] and "[it has the] capacity to express . . . a new order of things."[5] Paalen claims that photography is the "representative image" of his epoch; it is the conventional "image in which everyone recognizes his world without hesitation."[6] He criticizes prominent painters associated with the surrealist movement, particularly Salvador Dalí, for aping photographic realism in their work and producing reactionary "representative images" that reproduce objects that are readily identifiable in the real world, "instead of creating new forms."[7] However, Paalen goes on to clarify that since photography is aesthetically neutral it can be used in a revolutionary antirealist manner and prefigure new possibilities in art and thought. In the essay, he highlights the work of Man Ray, Brassaï, and Manuel Alvarez Bravo as exemplary cases of antirealist photography.

Photographs by these three artists had appeared in the pages of the surrealist journal *Minotaure* in the 1930s as well as in international surrealist exhibitions. By citing them, Paalen evokes continuity between the surrealists' approach to photography and his own, and indeed photography in *Dyn* often operates in dialogue with surrealist concepts and imagery. Yet while Alvarez Bravo was a regular contributor to *Dyn,* Man Ray was not featured at all, and only one two-page spread of photographs by Brassaï is included in the second issue of *Dyn* to accompany Paalen's article "About the Origins of the Doric Column and the Guitar-Woman." It is unlikely that Paalen would have wanted to feature photographers too closely associated with surrealism, given that he was attempting to distance himself from the movement and seeking to explore a new aesthetic. Instead, he often reached out to the photographers around him in Mexico City who, like him, were interested in examining and documenting the Americas and its indigenous heritage. So why did Paalen highlight Man Ray, Brassaï, and Alvarez Bravo in "The New Image" and what can that tell us about his approach to antirealist photography?

Although Man Ray and Brassaï experimented with tampering and manipulating the photographic image in the pages of surrealist journals, this does not seem to be why Paalen featured their work in his essay. *Dyn* does not include any of the experimental antirealist photographic techniques that we tend to associate with surrealism, techniques that would have been evident in André Breton's New York–based journal, *VVV.* It is more likely that Paalen highlighted these artists because their photography had at times destabilized the photographic truth of documentary realism. Man Ray collapsed the boundaries between documentary and artistic modes of representation by employing the play of light and shadow to reframe African artifacts "as found objects exploited for their visual and

conceptual potential."[8] Brassaï's photographic exploration of the Parisian nocturnal landscape in the 1930s occupies a complex position between documentary realism and staged artistic photography—he often posed his subjects, setting up lights and transforming reality into a mise en scène. Alvarez Bravo developed a realist style of photography in the 1930s that focused on the everyday lives of the mostly urban and rural working class, but it was a realism infused with symbols and hidden meanings.

In *Dyn*, photography of the anthropological and archaeological other oscillates between documentary and antirealist photography. Paalen's interest in ethnography and his fascination with the inherent unreliability of the visible world continues a tradition begun by the surrealists. Surrealism developed alongside, and intersected with, the emerging discipline of ethnography during the 1920s and 1930s; at the same time, surrealists responded to new research by psychologists and physicists who suggested that reality was not always what it seemed. Paalen extended this interest in *Dyn* and showcased ethnographic studies of pre-Columbian cultures while also drawing on new developments in science and art to develop his idea of a "potential concept of reality." He argued for an art that would not represent reality but "participate in the very making of reality."[9]

### EVA SULZER AND THE *TOTÉMIQUE* LANDSCAPE
Sulzer cofinanced *Dyn* with Mexican editor Octavio Barreda and was one of the journal's most active contributors.[10] Her essays, poems, and book reviews, as well as numerous photographic reproductions of artifacts from her extensive collection of pre-Columbian art, are included in *Dyn*'s pages. Sulzer's most significant contribution to *Dyn*, however, was her own photography. She was responsible for more photographs in the journal than any other photographer, and her images of the landscapes and artistic traditions of the First Nation peoples of the northwest coast of British Columbia and southeast Alaska appear in every issue. She amassed these photographs during a three-month expedition through the region with Paalen and French painter and poet Alice Rahon in the summer of 1939.

Sulzer's photography was extolled by Paalen and others in the *Dyn* group for its documentary and artistic significance. *Dyn*'s contributing editor, artist-archaeologist Miguel Covarrubias, selected several photographs by Sulzer to illustrate his publication *El arte indígena de norteamérica* (1945). Sulzer's work was also meaningful to Peruvian poet César Moro, a regular *Dyn* contributor, whose papers include a photograph by Sulzer of a pre-Columbian pyramid (fig. 2).[11]

Paalen used Sulzer's photographs as illustrations to his essay on the significance of totemism in the Americas, "Totem Art," published in the Amerindian double issue of *Dyn* in 1943. He also presented Sulzer's photographs in a more artistic context by including them as full-page images interspersed throughout the journal—particularly between extracts from his unfinished book "Paysage totémique," installments of which were published in nearly every issue of *Dyn*.

"Paysage totémique" comprises three texts about the journey along the northwest coast of British Columbia and southeast Alaska, and Paalen's verbal and Sulzer's visual accounts of the trip overlap and intersect. Sulzer's photographs depict deserted landscapes from a distance and close-up shots of First Nation totems. The images are mostly devoid of people. Each photograph insists on nature, on a denseness of vegetation and a landscape that comes alive, devouring what once was. *Ancient Haida Sculpture in the Forest near Masset* portrays a cropped totem engulfed by the branches of trees in a forest (fig. 3). The monumental sculpture almost seems to be traveling back through time, slowly reverting back to its original state as a large

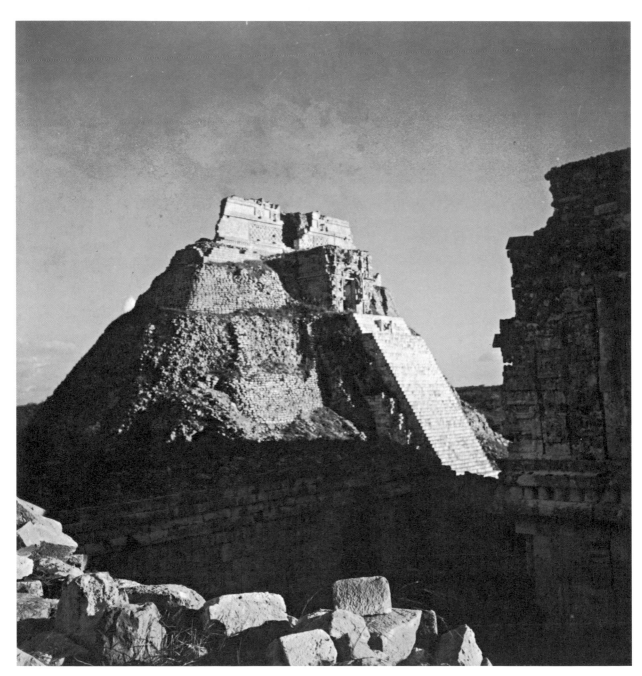

**Fig. 2.**                                          **Eva Sulzer (Swiss, 1902–90)**
Pre-Columbian pyramid in Uxmal, Yucatán, Mexico, ca. 1940–45,
gelatin silver print, 20.5 × 19.4 cm (8⅛ × 7⅝ in.)
Los Angeles, Getty Research Institute, 2001.M.21 (box 8)

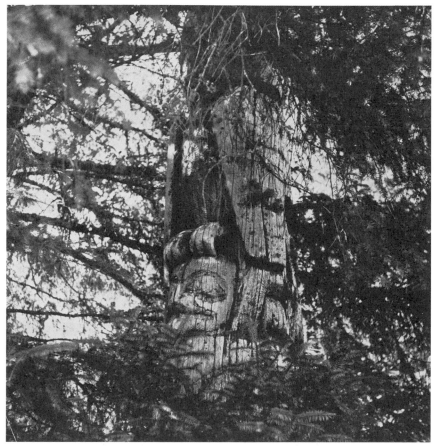

**Fig. 3.**                    **Eva Sulzer (Swiss, 1902–90)**
*Ancient Haida Sculpture in the Forest near Masset*, 1939
From *Dyn*, no. 1 (1942): 49

**Fig. 4.**              **Eva Sulzer (Swiss, 1902–90)**
*. . . when we opened the door of this great "community house,"*
1939, photographic print from original negative
Mexico City, Collection of Mrs. Gruen

tree. The photograph *... when we opened the door of this great "community house"* presents a communal house totem (fig. 4). We peer though the half-open doors of the wooden structure and see the sharp outlines of a totem face, staring back at us in the half-light. Byzantine tendrils of surrounding plant life encircle and penetrate the structure, and yet there seems to be something eternal and inviolable about the totem-spirit contained within.[12]

Meanwhile, in "Paysage totémique," Paalen interweaves his description of the totemic forms and forest landscapes of the northwest coast with various literary, artistic, and personal associations. He describes the totemic masks that he encounters in terms of the paintings of the early Renaissance artist Paulo Uccello.[13] He evokes associations with an image of a locomotive abandoned in a forest, a reference to Breton's example of convulsive beauty in his text "L'amour fou," published in *Minotaure* in 1934, and to a photograph that Benjamin Péret used to illustrate his text "La

nature dévore le progrès et le dépasse" in the same journal in 1937 (fig. 5). Indeed, there are clear visual similarities between Sulzer's photographs of totems and the photograph of the abandoned train; in both instances transitory examples of the human cultural endeavor are absorbed and consumed by an all-powerful nature. For Paalen, the forests of the Northwest Coast also conjure up memories of his childhood, and the landscapes he encounters seem to have been prefigured in a painting he created a year earlier titled *Totemic Landscape of My Childhood* (1937).

"Paysage totémique" evokes an experience of reality in which the past, the present, and the future are fused together. Presented in this context, Sulzer's anthropological documentary photographs of the Northwest Coast are reframed as antirealist images that seem to represent Paalen's ruminations on time and the process of perception where there is continuity between what is seen and what is remembered, between what is seen and what is imagined.

**Fig. 5.**        **Unattributed black-and-white photograph of a train**
**covered in vegetation accompanying Benjamin Péret's text**
**"La nature dévore le progrès et le dépasse"**
From *Minotaure*, no. 10 (1937): 20

### ANTIREALIST PHOTOGRAPHY AS CRITIQUE OF
### SURREALIST PAINTING

Paalen's use of antirealist photography is evident from issue 1 of *Dyn*. The first photograph in the journal depicts the mountain Ixtacihuatl (see fig. 1). On a clear day, Rahon, Paalen, and Sulzer would have been able to see Ixtacihuatl from the home they shared in San Angel. Viewed from the Valley of Mexico, the mountain commonly referred to as *la mujer dormida* indeed resembles a slumbering female form. The unusual cropping of the *Dyn* photograph frames the peaks across the picture plane close to the bottom of the photograph, and the high-contrast print juxtaposes alabaster summit ridges with a dark-toned sky and foreground. As a result, the photograph accentuates the resemblance of the mountain peaks to a sleeping woman lying on the ground with her body facing the sky. This view of Ixtacihuatl as sleeping woman is reiterated in Rahon's accompanying poem when she states, "Ixtacihuatl, anointed by the gods, the sleeping woman's face turned toward the rising sun."[14]

It is likely that Paalen and Rahon selected the image and poem in part to signal the important role that the pre-Columbian legacies of the Americas would assume in *Dyn* in the coming issues. The photograph alludes to a number of tropes and concepts that fascinated the surrealists: the female form as a source of erotic fascination and the marvelous (this is the only photograph in *Dyn* in which we see the depiction of the eroticized female form that is so prevalent in other surrealist journals, in particular *Minotaure*); the importance of dreams as an arena of unconscious suppressed desires; and an interest in mimicry as an expression of Breton's concept of convulsive beauty. The mapping of these tropes of surreality onto the Mexican landscape follows an established pattern that began with Breton's description of Mexico as a "surrealist place par excellence."[15] The photograph also appears to be in dialogue with the work of photographers and artists associated with surrealism,

such as Brassaï, whose experimental studies of female nudes as graphic forms (which appeared in *Minotaure* in the 1930s) reframe the female body as an unfamiliar erotic topography (fig. 6). The Ixtacihuatl photograph's overt relationship to surrealist concepts and imagery suggests that Rahon, who at this point still considered herself a surrealist, had primary responsibility for image selection. However, Paalen may also have been involved, given that the photograph was included in *Dyn* at a time when he was still working through his visual relationship to surrealism.

Whether or not Paalen took part in the image selection, he was certainly responsible for the placement. Here, a rupture with surrealism is evident. It is surely not coincidental that Paalen locates this image in close proximity to the French version of his text "The New Image," which includes a vigorous critique of Salvador Dalí's pseudophotographic paintings. The double-image effect of the Ixtacihuatl photograph, where what we see is both a slumbering female form and a snowcapped mountain, alludes to Dalí's experimentation with his paranoiac critical method as seen in such works as *Paranoiac Visage* (1935), where two distinct and incompatible images coexist in one image. By including a photograph of a real instance of doubling recorded photographically, Paalen seems to underline the redundancy of Dalí's realist approach. The photograph acts to illustrate Paalen's critique while also serving as an example of antirealist photography.

### *Indigenismo* and Antipicturesque Photography in *Dyn*

If the image of Ixtacihuatl introduces Paalen's antirealist aesthetic, it also hints at another tendency within the journal: the rejection of the picturesque. The photograph of Ixtacihuatl is attributed to H. B., presumably German-born pictorialist photographer Hugo Brehme.[16] Typically,

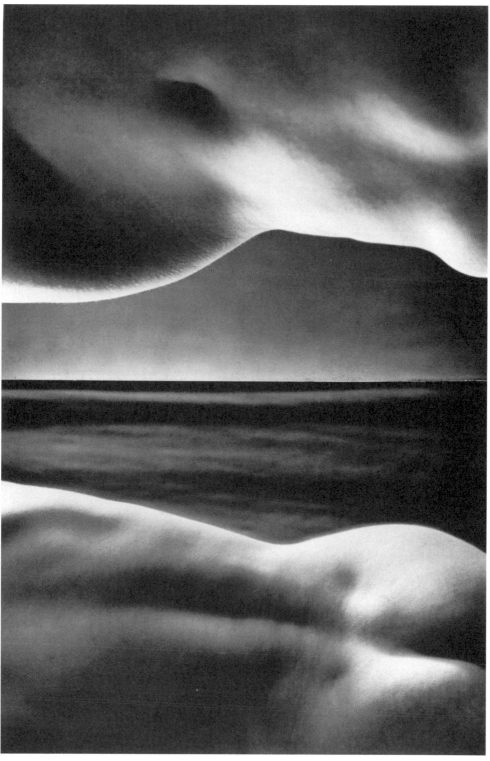

**Fig. 6.**                                    **Brassaï (Hungarian-born French, 1899–1984)**
*False Sky,* ca. 1932–34
gelatin silver print, 34.3 × 24.1 cm (13½ × 9½ in.)
Private collection

Brehme's photographs depict picturesque archetypal Mexican landscapes artistically framed by surrounding vegetation. Often his landscapes include indigenous men, women, and children, recording "a quaint and somewhat condescending scene to remind the tourist at home of the peaceful, complacent, and colorful poverty of rural Mexico."[17] The image in *Dyn,* however, bears little resemblance to Brehme's bucolic romantic style. Although similar to a possible Brehme photograph in Paalen's and his third wife Isabel Marín's papers at the Museo Franz Mayer in Mexico City (fig. 7), the version in *Dyn* appears to have been cropped, removing the picturesque trees framing Ixtacihuatl.[18] The cropping heightens the resemblance of the mountain to a sleeping woman and maps a surrealist-inspired discourse onto the region's topography, but it also interrupts a nationalist narrative where photography of the Mexican landscape is used to promote an idealized view of Mexico's indigenous heritage.

Brehme was involved in early struggles about how to represent Mexico and define *lo mexicano* after the revolution of 1910–20. Beginning in the 1920s, Mexican intellectuals and artists were encouraged to recover, explore, and promote the myths, traditions, and landscapes of Mexico's indigenous people that had been forgotten and undervalued during colonial and Porfirian rule. This was part of a government policy of modern *indigenismo,* in which legislators sought to rectify the historic economic and political marginalization of Mexico's native peoples and unite an ethnically, culturally, and socioeconomically diverse country through a shared narrative of national identity that exalted the uniqueness of Mexico's indigenous heritage.[19] While *indigenismo* began in the 1920s as a move toward cultural autonomy, by the 1940s it was part of official state discourse. Brehme's vision of a picturesque Mexico of cacti, volcanoes, clouds, and campesinos had gained popular currency by that time, and his essentialist vision would have

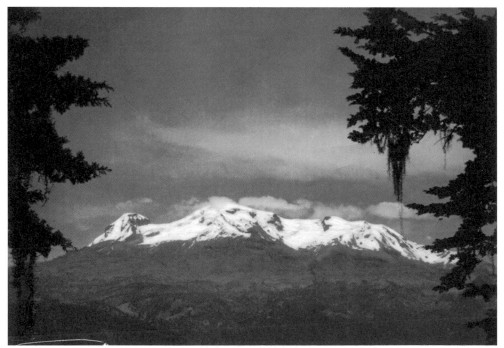

**Fig. 7.**     **Untitled photograph of Ixtacihuatl, n.d.,**
gelatin silver print, 14.9 × 21.2 cm (5 ⅞ × 8 ⁵⁄₁₆ in.)
Mexico City, Museo Franz Mayer, Isabel Marín and Wolfgang Paalen papers

been evident everywhere from the cinema to illustrated magazines to the visual arts.

For Paalen, pictorial *indigenismo* was anathema. He was resistant to the use of art for any political ends, stating that "the artist ought to refuse any order or offer that does not leave him perfect liberty of expression. He ought to refuse to collaborate in all political or commercial enterprises which treat art as a means only and not equally as an end."[20] In his editorial for *Dyn*, nos. 4–5, Paalen frames the integration of Amerindian forms into modern art as the "negation of all exoticism." "For it presupposes an understanding that abolishes the frontiers which are unfortunately still emphasized by the quest for the picturesquely local, and preserved through intellectual provincialism."[21]

Paalen was also sensitive to the effects of colonization on indigenous groups and to the discrepancy between imagery produced for tourist consumption and the lived reality of peoples whose traditions and way of life were marginalized and under threat. In "Totem Art," he discusses the effects of colonization on the indigenous communities of the northwest coast of British Columbia and southeast Alaska:

> There remains the question of white influence. Here as everywhere else where it went hand in hand with progressive domination, it rapidly destroyed indigenous life. . . . [W]e must not always, in discreet silence, overlook the fact that what remains of these creators of Totem Art in British Columbia live even today under continued religious persecution. . . . To limit the creative power of these peoples to petty decorative tasks, and to confound the products of the souvenir market with their authentic expressions merely degrades their great art which was of entirely collective purpose: an art for consummation and not for individual possession.[22]

## CONTRASTING PERSPECTIVES: CÉSAR MORO, MARTÍN CHAMBI, AND ROSA ROLANDO

Perhaps *Dyn*'s most vocal critic of Latin American *indigenismo* was César Moro. In 1939, he coedited the short-lived surrealist publication *El uso de la palabra*. The first and only number of this ephemeral journal included Moro's article "A propósito de la pintura en el Peru," a scathing and insightful critique of pictorial *indigenismo,* the dominant school of Peruvian painting in the 1930s and 1940s. For his contribution to the Amerindian double issue of *Dyn,* "Coricancha: The Golden Quarter of the City," Moro draws on the representation of invisibility and distance to critique nationalist rhetoric. His evocative prose description of the Coricancha temple, located in Cuzco (the historic capital of the Incan empire in Peru), is accompanied by a series of landscape photographs by one of the first indigenous Latin American photographers to receive international critical acclaim, Martín Chambi. In his text, Moro nostalgically celebrates a culture that he regards as having vanished forever. For him, only "the earth has remained." The former civilization is now merely a "millennial echo . . . in the midst of silence," occasionally interrupted by the "vulgarly episodic interference of the horns of tourism."[23] The selection of documentary images complements the conceptual thrust of his text in interesting ways.[24] It includes images of the amphitheater of Kenko, the palace of Huayna Capac, the portal of the ruins of Sacsayhuaman in Cuzco, and Machu Picchu (another important center of Incan civilization); and it comprises close-up shots of stone edifices and ruins and panoramic aerial views (fig. 8). Most of the photographs are devoid of human presence, and overall they create a sensation of distance and absence. As with Sulzer's images of the northwest coast of British Columbia and southeast Alaska, Chambi's photographs confront us with the passage of time, as a once-great civilization is reduced to a collection of stones.

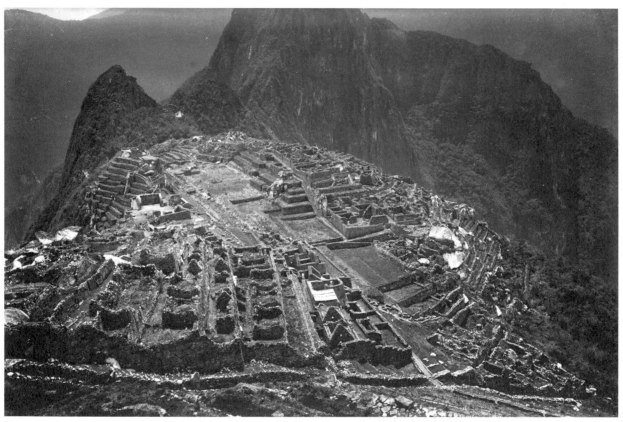

**Fig. 8.**
**Martín Chambi (Peruvian, 1891–1973)**
*Panoramic View of Machupicchu,* black-and-white photograph, 1928
Cuzco, Peru, Archivo Fotografico Martín Chambi

If Moro's text and Chambi's images combine to disrupt the official nationalist narrative in Peru and Mexico in the 1930s and 1940s—in which the pre-Columbian legacy of the indigenous peoples of the Americas was mobilized by elites as a powerful symbol of a continuous cultural identity and tradition—Rosa Rolando's photography aligns more closely with the official rhetoric of Mexican *indigenismo*.

Rolando's first photograph in *Dyn* is a full-page close-up shot of an indigenous schoolgirl from Tehuantepec that appears in the Amerindian issue (fig. 9). In her right hand, the girl holds a socialist education schoolbook. From the mid-1930s to 1940, Mexican president Lázaro Cárdenas developed a socialist educational and cultural program that was inspired by the ideas of Soviet educator Anton Makarenko. In Rolando's image, shot from below, the young girl is presented with authority. Her posture is erect, her face slightly turned as she stares defiantly off into the distance. The image is social realist in style and celebrates the girl's dignity while glorifying the socialist educational policies of Cárdenas. Opposite the young schoolgirl, Rolando's second image in this issue is of three Oaxacan children gazing sweetly out at the viewer.

Rolando's photographs follow an English translation of a poem about the Aztec god Xiuhtecuhtli and a full-page photograph of a pre-Columbian clay sculpture of a Tarascan couple. Thus the indigenous children are presented as heirs to the rich and vibrant legacy of pre-Columbian culture.

The photographs and their placement were probably determined by Rolando's husband Miguel Covarrubias, a Mexican caricaturist who, with his groundbreaking studies of Mesoamerican cultures, forged a reputation as a prominent and respected anthropologist and archaeologist. He contributed scholarly essays, photographs, illustrations, and editorial expertise to *Dyn*.

Covarrubias was a key actor in Mexican *indigenismo*. During Cárdenas's presidency (1934–40), anthropology and archaeology were promoted as a means of studying and promoting Mexico's past. Both the Instituto Nacional de Antropología e Historia and the Escuela Nacional de Antropología e Historia were founded under Cárdenas's administration, and artists with no previous training took on the roles of anthropologists and archaeologists.[25]

The juxtaposition of photographs of ancient pre-Columbian culture with Rolando's images of contemporary Mexican people recalls Covarrubias's use of photography in his contributions to the journal. Take, for example, the imagery in his ethnographic account of his journey to La Venta, a pre-Columbian archaeological site of the Olmec civilization, in the sixth issue of *Dyn*. Covarrubias juxtaposes a photograph of a colossal head located in the Mexican state of Tabasco with a portrait photograph of a contemporary indigenous Totonac woman from Veracruz and a watercolor illustration of a wooden mask discovered in Guerrero (figs. 10, 11).[26]

While Rolando's celebration of Mexico's indigenous peoples in her photography aligns with Mexican *indigenismo,* her photographs depict people of the Americas in a blatantly antipicturesque style. The children in both *Dyn* images occupy the entire frame of the photograph and are presented as significant in their own right—not simply as one more element in a bucolic rural scene. They are individuals who should be celebrated, admired, and afforded education and rights. This approach recalls Covarrubias's "tenderness for the disinherited."[27] His desire to understand and describe the cultural development of the indigenous peoples of Mesoamerica was also accompanied by a deep concern with the living conditions of the indigenous communities he came into contact with in the slums of Mexico City and during his excavations.

**Fig. 9.**                    **Rosa Rolando (American, 1895–1970)**
*Schoolgirl of Tehuantepec,* ca. 1943
From *Dyn,* nos. 4–5 (1943): 66

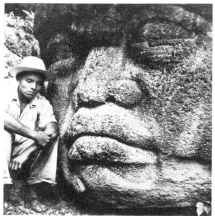

One of the colossal heads of La Venta. 2,56 mts. high. Photo Miguel Covarrubias.

Totonac woman of Papantla. Note the
physical likeness with the colossal heads
of La Venta. Photo Donald Cordry.

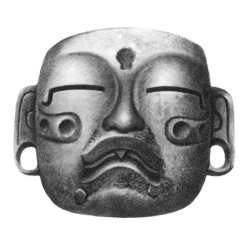

Mask of hard wood, about 25 cmts. high, carved in one piece with traces
of cinnabar and blobs of copal resin around the mouth which held a mosaic
of jadeite plaques of which three remain below the mouth. It was found
in a cave on the Cerro de la Cruz, Cañón de la Mano, Guerrero, together
with the metal ornaments of a decayed saddle. This cave was the hideout
of the famous bandit Agustín Lorenzo. (Middle of the nineteenth century.)
Drawn from the original, now in a New York private collection.

On the opposite page:
Four small jadeite objects in the style of La Venta.

Top: Little mask from Zumpango del Río, Gro. 3,5 cmts. Coll. M. Co-
varrubias.

Middle left: Jaguar sitting on a throne (?) from the Mixteca, Oax. 6,5
cmts. Coll. M. Covarrubias.

Middle right: Small axe painted with cinnabar found by Stirling in a tomb
at La Venta. 11 cmts. National Museum of Mexico.

Below: Reclining youth from San Gerónimo, Gro. 10 cmts. American
Museum of Natural History, New York.

Center: Sphinx-like demon, clay, China. After Wilhelm Hausenstein:
"Barbaren und Klassiker." Note the likeness with the "jaguar sitting on
a throne."

Water-colors and drawings by Miguel Covarrubias.

**Fig. 10.**  **Black-and-white photograph
of a colossal head
at La Venta by Miguel Covarrubias
(Mexican, 1904–57)
and black-and-white photograph
of a Totonac woman of
Papantla by Donald Cordry (American, 1907–78)**
From *Dyn*, no. 6 (1944): after p. 24

**Fig. 11.**  **Watercolor drawing of a mask
of hard wood from Guerrero, Mexico,
by Miguel Covarrubias
(Mexican, 1904–57)**
From *Dyn*, no. 6 (1944): after p. 24

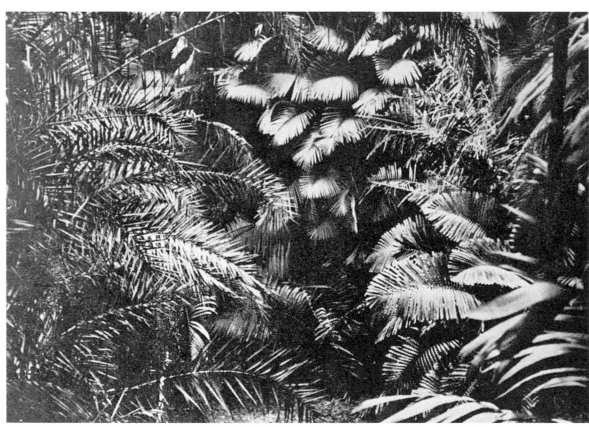

**Fig. 12.**                                **Rosa Rolando (American, 1895–1970)**
*In the Buitenzorg Gardens of Java near Batavia,* ca. 1935
From Dyn, no. 6 (1944): after p. 36

While Covarrubias's and Rolando's support of social justice dovetailed with the anticolonial impulses of Paalen and other members of the *Dyn* group, it is likely that Rolando's photographs were too overtly political for Paalen and a little too removed from his antirealist aesthetic taste. Paalen's treatment of two photographs by Rolando in *Dyn,* no. 6, is revealing in this respect: he frames Rolando's anthropology-inspired images—photographs of the Buitenzorg Gardens of Java near Batavia, Indonesia (fig. 12), and the rice fields of Selat, West Bali—using an antirealist aesthetic. The photographs lack any anchoring contextual information, and neither is readily identifiable. The high-contrast print brings out the graphic pattern-like quality of the landscape, while the dense vegetation seems to refer back to Sulzer's images of the Northwest Coast and Paalen's ruminations on his totemic landscapes.

## Synthesis: Antirealist and Antipicturesque Photography in *Dyn*

Alvarez Bravo's photographs first appear in *Dyn,* no. 2, with a symbolist-inspired photograph, *Portrait of the Eternal* (fig. 13). The image depicts Mexican artist, actress, poet, and personality Isabel Villaseñor gazing into a mirror as she combs her long and luxuriant hair. The surrealists frequently used mirrors as a way of expressing their interest in the unstable, fractured subject revealed by psychoanalysis. Indeed, Alvarez Bravo's image of a woman with hair obscuring her face recalls Belgian surrealist Raoul Ubac's *Portrait in a Mirror,* which appeared alongside Pierre Mabille's article "Miroirs" in *Minotaure* in 1938 (fig. 14). Alvarez Bravo's enigmatic imagery resonated with the surrealists. Although he was never officially a member of the movement, his photographs appeared in *Minotaure,* particularly within the pages of Breton's "Souvenir du Mexique," published in 1938, as well as in surrealist exhibitions, including the *Exposición internacional del surrealismo* (1940), organized in Mexico City by Paalen, Moro, and Breton.

In total, Alvarez Bravo contributed six photographs to the journal—three of which are photographs of pre-Columbian artifacts. Doris Heyden's photography first appears in the third issue. Alvarez Bravo and Heyden would regularly attend open houses at Paalen, Rahon, and Sulzer's home in San Angel and, as the pages of *Dyn* attest, Alvarez Bravo frequently photographed objects from Paalen's, Sulzer's, and Covarrubias's collections of pre-Columbian art. We know that Paalen carefully selected images by both photographers for inclusion in the journal,[28] and it is arguably with Alvarez Bravo's and Heyden's photography that we see a synthesis between Paalen's interest in antirealist photography and his antipicturesque approach to pre-Columbian culture.

By the mid-1930s, Alvarez Bravo had moved away from the formal and abstract photographic style of his formative years and adopted an increasingly realist style, a kind of urban visual anthropology that took the lives and landscapes of Mexico's indigenous peoples as its subject. But this was not straightforward documentary realism; instead, Alvarez Bravo crafted photographs infused with poetic associations, which often framed "the contradictions of Mexico's urban and rural life into social statements."[29]

Alvarez Bravo's *Fable of the Dog and the Cloud* (fig. 15) appears in the third issue of *Dyn* amid the pages of Henry Miller's essay "Preface to Parker Tyler's 'America's Hallucination.'" The photograph depicts a ramshackle, improvised home with an assortment of scrap—including metal, wicker, and various wooden containers—in the yard. The house is constructed from found castoffs of wood and cardboard, and a makeshift roof is held down by bricks. The impoverished but resourceful owner is noticeably absent. In the foreground, a scruffy-looking dog feeds from a container in the yard. A large white cloud hovers above.

While the photograph appears realist in style, the title's insistence on the significance of the dog and the cloud

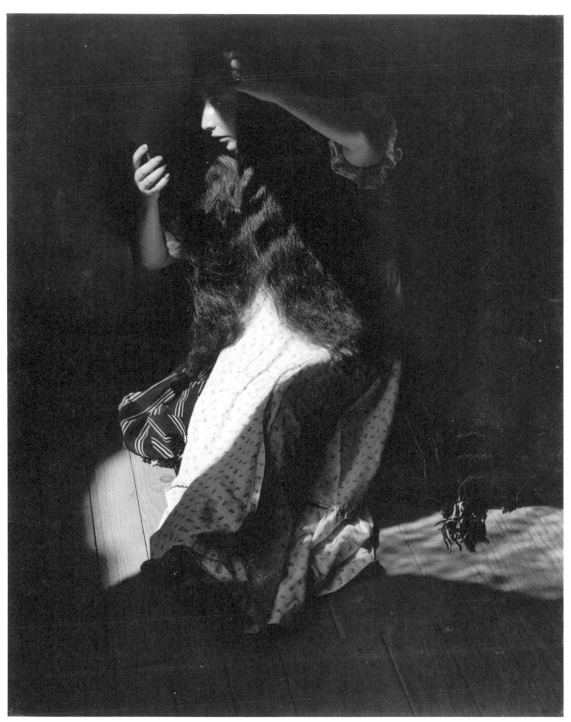

**Fig. 13.**               **Manuel Alvarez Bravo (Mexican, 1902–2002)**
*Portrait of the Eternal,* 1935, gelatin silver print, 24.3 × 19.2 cm
(9⁹⁄₁₆ × 7⁹⁄₁₆ in.)
Los Angeles, J. Paul Getty Museum, 92.XM.23.30

**Fig. 14.**

**Raoul Ubac (Belgian, 1910–85)**
*Portrait in a Mirror,* 1938
From *Minotaure,* no. 11 (1938): 17

evokes symbolic associations in the mind of the viewer. For one, the figure of the dog features prominently in Mayan and Aztec pottery and codices. In Mayan mythology, dogs carried the newly deceased across a body of water to the underworld. The dead were also sometimes buried with dogs. Among the Aztecs, the god Xolotl was a monstrous dog who had associations with lightning and death. Covarrubias's article "Tlatilco: Archaic Mexican Art and Culture," in the Amerindian issue of *Dyn,* includes photographs of Archaic dog-like figurines collected from Tlatilco, a pre-Columbian burial site discovered just outside of Mexico City on the grounds of a brick factory (see this volume, p. 28, fig. 17). At the site, Covarrubias and others found offerings to the dead such as sacrificed *escuintli* (hairless) dogs, as well as pottery

vessels including a ceramic dog wearing a humanoid face. Centuries later, dogs continued to have significance in indigenous folk traditions, as demonstrated by Carlos Mérida's depiction of two individuals dressed as dogs for his portfolio of prints *Carnival in Mexico* (fig. 16).

The cloud, too, is meaningful in Mesoamerican folklore and myth. The Maya believed that the deceased became clouds, butterflies, and stars. Perhaps more important than its pre-Columbian significance, however, is the role the cloud played in the production of an idealized image of rural Mexico. Works by Hugo Brehme and others depict campesinos in idyllic Mexican landscapes, framed by clouds in the sky (fig. 17). With *Fable of the Dog and the Cloud,* Alvarez Bravo appears to have appropriated elements from

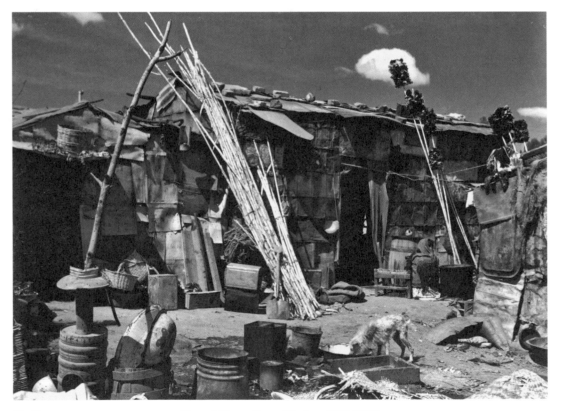

**Fig. 15.**  **Manuel Alvarez Bravo (Mexican, 1902–2002)**
*Fable of the Dog and the Cloud,* 1930–40, gelatin silver print,
16.7 × 22.7 cm (6⅝ × 9 in.)
Los Angeles, J. Paul Getty Museum, 92.XM.23.44

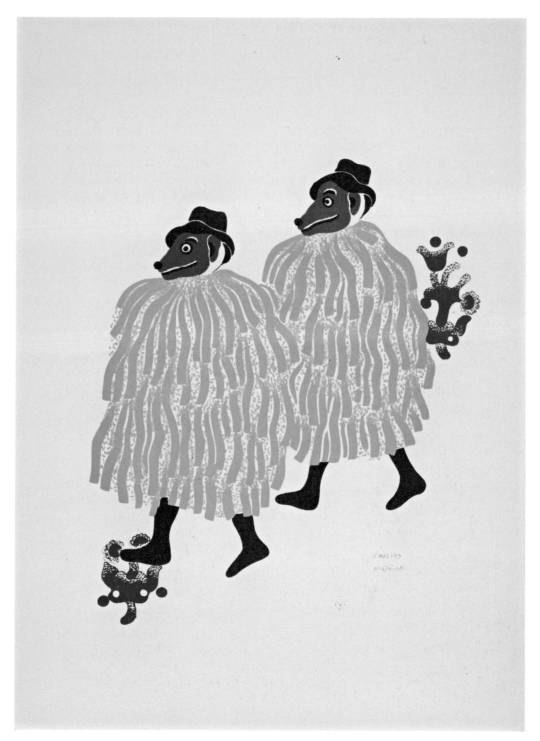

**Fig. 16.**                    **Carlos Mérida (Guatemalan, 1891–1985)**
People dressed as dogs for the Fiesta of Huchuenchis in Huixquilcan,
Mexico, ca. 1940, color lithograph print, 44.5 × 31.8 cm (17½ × 12½ in.)
From *Carnival in Mexico* (Mexico City: Lithographic Department of the
Talleres Gráficos de la Nación, 1940), plate 3
Los Angeles, Getty Research Institute, 89-B18431

the vocabulary of picturesque *indigenismo* and used them to cut against its nationalist message. He presents us instead with the reality of poverty and marginality experienced by indigenous peoples in Mexico.[30]

Doris Heyden was already a practicing photographer when she traveled to Mexico in the 1940s and met and married Alvarez Bravo. The girls in *Junio 1942,* one of only two photographs that Heyden contributed to *Dyn,* are standing on the roof of a building (fig. 18). To their left are two cylindrical water storage containers whose curvilinear grooves recall Paalen's oscillator paintings of the 1940s.[31] The girl closest to the picture plane has her back to us. She leans into the wall surrounding the roof and clasps her hands around the waist of the other girl. The second young woman stands at an oblique angle to the picture plane. Her arms are raised in a gesture that recalls the *orans* praying position, common to most ancient religions. This association just

adds to the overall ambiguity of the image. The photograph is shot in a realist style but the image's enigmatic, lyrical quality transforms it into an antirealist work.

While at first glance there is very little beyond the photograph's title to associate it with the Americas as subject, as one continues to read subsequent issues of the journal, certain relationships between Heyden's photograph and pre-Columbian culture begin to emerge. Covarrubias's aforementioned "Tlatilco: Archaic Mexican Art and Culture" describes Archaic clay figurines discovered at the burial site. Among them are two-headed females, which Covarrubias depicts in exquisitely rendered watercolor drawings that accompany his article (fig. 19). In his text Covarrubias draws associations between the figurines and the principle of duality—so important to pre-Columbian religious practices. It is quite possible that Heyden recognized this visual association. Her approach seems to have much in common with

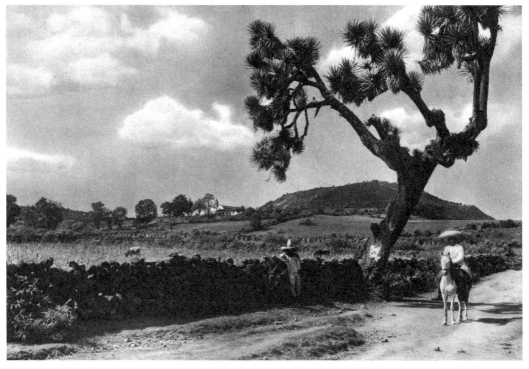

**Fig. 17.**                           **Hugo Brehme (German, 1882–1954)**
Mount Calvary (El Calvario) in Pátzcuaro in the state of Michoacán,
Mexico, ca. 1920–23
From *Picturesque Mexico: The Country, the People and the Architecture*
(London: Jarrolds, 1925), 196
The Bancroft Library, University of California, Berkeley

Alvarez Bravo's in *Fable of the Dog and the Cloud,* and it may be that both photographers were reaching toward an artistic language that would incorporate pre-Columbian motifs and references in a subtle way that disavowed the picturesque and pushed the boundaries of modern photography.

Paalen likely admired the way that *Fable of the Dog and the Cloud* and *Junio 1942* inverted the language of picturesque *indigenismo.* But he would have also appreciated how the photographs destabilized documentary realism. Like Sulzer's photographs, Alvarez Bravo's and Heyden's antirealist images fuse the past, present, and future—what has been, what is, and what might be—into images of the possible. In this case, however, Paalen does not need to juxtapose the images with text to construct this meaning— indeed, the meaning is located independently in the photographs themselves.

Through the six issues of *Dyn,* Paalen sought to present an antirealist photographic aesthetic. He repurposed antipicturesque documentary photography of the indigenous peoples as well as landscapes and traditions of the Americas, often produced for anthropological and archaeological purposes; and he used juxtaposition—of text and image—and decontextualization to invoke unexpected meanings. Paalen also sought out photographers whose work used the language of documentary realism against itself to explore the symbolic associations of the everyday. For Paalen, the idea that documentary photography can provide us with direct access to "reality" is inherently fictitious. "Reality" is merely a layering of associations from the past and imaginative projections of the future. There is no "chaste sword between perception and interpretation," only a space of possibility "between what [*we*] see and what [*we*] know."

## Notes

Many thanks to Dawn Ades, Lucy Bradnock, Annette Leddy, and Laura Santiago, whose insightful comments and suggestions helped me to refine this text. Thanks also to Rebecca Zamora, Raquel Zamora, and Jannon Stein for their research assistance.

**1.** Wolfgang Paalen, "Paysage totémique," *Dyn,* no. 1 (1942): 48. All translations are mine.

**2.** Wolfgang Paalen, epigraph to *Dyn,* no. 1 (1942): frontispiece.

**3.** *Dyn* also features photographs by US-born Donald Cordry, a self-taught Mesoamerican scholar and ethnographer of the arts and crafts of Indian Mexico and a collector of masks and textiles; and Giles Greville Healey, a self-taught Mayan archaeologist best known for his photographs of pre-Columbian painted murals at the Mayan site of Bonampak and for his feature film *Maya through the Ages.*

**4.** Wolfgang Paalen, "The New Image," *Dyn,* no. 1 (1942): 13.

**5.** Paalen, "The New Image," 9.

**6.** Paalen, "The New Image," 10.

**7.** Paalen, "The New Image," 12.

**8.** Wendy A. Grossman, *Man Ray, African Art, and the Modernist Lens* (Washington, D.C.: International Arts and Artists, 2009), 73.

**9.** Carter Stone and Wolfgang Paalen, "During the Eclipse," *Dyn,* no. 6 (1944): 20.

**10.** Amy Winter, *Wolfgang Paalen: Artist and Theorist of the Avant-Garde* (Westport, Conn.: Praeger, 2003), 123.

**11.** Sulzer's photography was also admired by *Dyn*'s readers. In a letter praising Paalen for his work on the Amerindian double issue of the journal, Bruce Inverarity, director of the Santa Fe Museum of Arts and Crafts, singled Sulzer out for praise, stating that she "has done a very good set of photos showing great selection of composition." Inverarity goes on to note that totem poles are "not easy to photograph in their natural surroundings." Letter from Bruce Inverarity to Wolfgang Paalen, March 1944, Paalen Archiv Berlin.

**12.** Sulzer's images relate to photographs of British Columbia totems accompanying Swiss-American surrealist Kurt Seligmann's ethnographic text "Entretiens avec un Tsimshian," which appeared in *Minotaure* in 1938, and reflect a broader interest among the surrealists in the 1930s and 1940s in documenting and collecting First Nations art.

**13.** Elza Adamowicz convincingly argues that Paalen filters his description through George Pudelko's article on the Uccello published

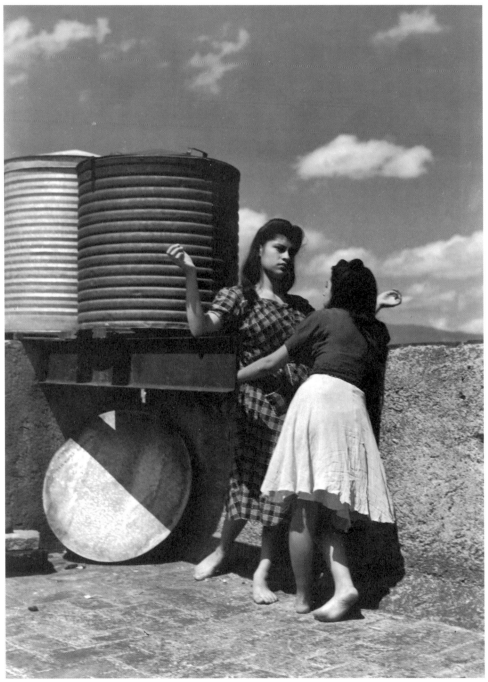

**Fig. 18.**
**Doris Heyden (American, 1915–2005)**
*Junio 1942*, 1942, gelatin silver print, 22.9 × 16.5 cm (9 × 6½ in.)
Museo Franz Mayer, Archivo Wolfgang Paalen

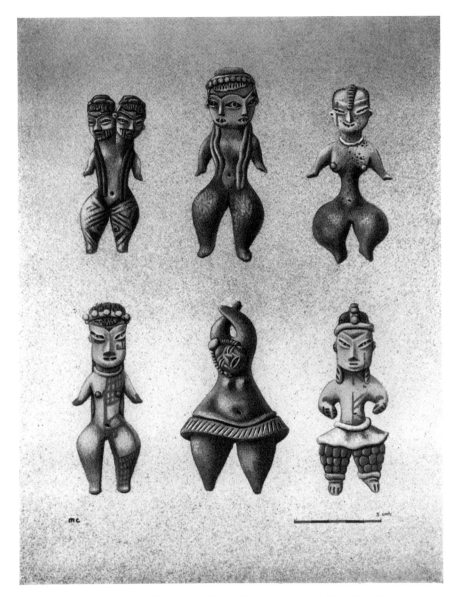

Plates IX, X • Archaic figurines from Tlatilco • Water-color and drawings by Miguel Covarrubias.

**Fig. 19.**
**Miguel Covarrubias (Mexican, 1904–57)**
*Archaic Figurines from Tlatilco,* ca. 1940
From *Dyn,* nos. 4–5 (1943): after p. 42

in *Minotaure* in 1936. See Elza Adamowicz, "The Space of the Other," in idem, ed., *Crossings/Frontiers* (Bern: Peter Lang, 2006), 212.

**14.** Alice Rahon, untitled poem, *Dyn,* no. 1 (1942): 44. Ixtacihuatl has an important place in Aztec mythology. According to legend she was a princess who died of a broken heart after being falsely told that her lover, the warrior Popocatepetl, had been killed in battle. Grief-stricken, Popocatepetl carried Ixtacihuatl's body outside of the Aztec capital of Tenochtitlán to bury her. Touched by the couple's suffering, the gods transformed them into snowcapped mountains so that they could be together for eternity.

**15.** Rafael Heliodoro, "Diálogo con André Breton," *Universidad* 5, no. 29 (1938): 128–29.

**16.** Paalen had Brehme's photograph in his collection.

**17.** Amy Conger, *Edward Weston in Mexico, 1923–1926* (Albuquerque: Univ. of New Mexico Press, 1983), 56.

**18.** While this photograph is not attributed, it is likely that Brehme is the author. The image has stylistic similarities to another Brehme photograph found among Paalen's papers at the Paalen Archiv in Berlin. *Dyn* contributor Alvarez Bravo was a former student of Brehme's and may have introduced Paalen to his work.

**19.** Although *indigenismo* is traditionally associated with Mexico and Peru, recent scholarship by such figures as US art history professor Michelle Greet has demonstrated its distinct regional manifestations in such diverse Latin American countries as Ecuador and Columbia.

**20.** Stone and Paalen, "During the Eclipse," 17.

**21.** Wolfgang Paalen in *Dyn,* nos. 4–5 (1943): n.p.

**22.** Wolfgang Paalen, "Totem Art," *Dyn,* nos. 4–5 (1943): 17–18.

**23.** César Moro, "Coricancha: The Golden Quarter of the City," *Dyn,* nos. 4–5 (1943): 75.

**24.** Moro asked his friend and colleague Emilio Adolfo Westphalen to help him find a photographer whose work could accompany his article. Although he did not directly select the photographer, Moro was quite specific about the locations he wanted to include. Letter from César Moro to Emilio Adolfo Westphalen, 21 July 1942, Emilio Adolfo Westphalen papers regarding surrealism in Latin America (2001.M.21), Getty Research Institute, Los Angeles. Thanks to Dawn Ades for informing me about this correspondence.

**25.** Such diverse artists as Covarrubias, Diego Rivera, Roberto Montenegro, Fernando Leal, and Carlos Mérida collected, documented, exhibited, illustrated, wrote about, and photographed

artifacts and ruins of pre-Columbian cultures as well as the culture and traditions of indigenous peoples. Archaeological research produced new scholarship on pre-Columbian civilizations, fostered pride in Mexico's indigenous past, and fueled a growing tourist industry.

**26.** Covarrubias underlines their visual similarities to support his argument that Olmec was the mother culture from which sprang other pre-Columbian civilizations, such as the Maya and Zapotec.

**27.** Octavio Barreda, "Elena Poniatowska reconstruye la vida de Miguel Covarrubias," *Novedades* (1957): n.p., reprinted in Adriana Williams, *Covarrubias* (Austin: Univ. of Texas Press, 1994), 105.

**28.** Interview between Courtney Gilbert and Doris Heyden, October 1977. Cited in Courtney Gilbert, "'The (New) World in the Time of the Surrealists': European Surrealists and Their Mexican Contemporaries" (Ph.D. diss., University of Chicago, 2001), 272.

**29.** Weston Naef, ed., *Manuel Alvarez Bravo: Photographs from the J. Paul Getty Museum* (Los Angeles: The J. Paul Getty Museum, 2001), 6. Alvarez Bravo was a former student of Hugo Brehme's. See John Mraz, *Envisioning Mexico: Photography and National Identity* (Durham, N. C.: Duke Univ. Press, 2001) for an insightful analysis of the opposing tendencies of picturesque and antipicturesque in photographic representations of Mexico.

**30.** Alvarez Bravo's enigmatic images of Mexico and indigenous people in *Dyn* contrast with the photographs that Breton selected to accompany "Souvenir du Mexique," an account of his journey to Mexico. Breton uses Alvarez Bravo's photography to illustrate what he feels is important about Mexican culture, in particular the obvious tropes of its revolutionary history and present (*Striking Worker Murdered* [1934]) and the prevalence of death and death's reconciliation with life (*Recent Grave* [1937]). See Gilbert, "'The (New) World in the Time of the Surrealists,'" for a fascinating discussion about how Breton uses text and image in "Souvenir du Mexique" to present Mexico as part of the surrealist landscape.

**31.** In her essay "The Painting Aesthetic of *Dyn*" (this volume, p. 9–34), Annette Leddy discusses the influence of physics and in particular Louis de Broglie's *Matière et lumière* (1937) on the development of Paalen's oscillator paintings. Given that Heyden's photograph is featured among the pages of Paalen's article "Art and Science," Paalen's selection of the image may have been prompted by the visual correspondence between his work and the water towers. Thanks to Annette Leddy for pointing out this visual relationship.

# EXHIBITION CHECKLIST

## PREPARED BY REBECCA ZAMORA

Garden scene with Wolfgang Paalen, Alice Rahon, and Eva Sulzer, ca. 1942, gelatin silver print, 8.9 × 5.1 cm (3½ × 2 in.)
Museo Franz Mayer, Archivo Wolfgang Paalen

### Farewell to Surrealism

Wolfgang Paalen with his *Portrait of André Breton,* ca. 1942, gelatin silver print, 6.4 × 6.4 cm (2½ × 2½ in.)
Museo Franz Mayer, Archivo Wolfgang Paalen

Wolfgang Paalen (Austrian, 1905–59)
*Totemic Landscape of My Childhood,* 1937
From *Minotaure,* nos. 12–13 (1939): after p. 16
Getty Research Institute, 84-S173

André Breton (French, 1896–1966), Wolfgang Paalen (Austrian, 1905–59), and César Moro (Peruvian, 1903–56), eds.
*Exposición internacional del surrealismo,* exh. cat. (Mexico City: Galería de Arte Mexicano, 1940)
Getty Research Institute, 92-B24763

Wolfgang Paalen (Austrian, 1905–59)
"Farewell au surréalisme" and "Seeing and Showing," accompanied by untitled woodcut print
From *Dyn,* no. 1 (1942): 26–27
Getty Research Institute, 2571-405

César Moro standing in front of Wolfgang Paalen's *Combat of the Saturnian Princes II,* ca. 1940, gelatin silver print, 17.1 × 12.7 cm (6¾ × 5 in.)
Getty Research Institute, 2001.M.21

### César Moro and Dyn

César Moro buried up to his head in the sand, ca. 1935, gelatin silver print, 8.6 × 12.1 cm (3⅜ × 4¾ in.)
Getty Research Institute, 980029 (box 1, folder 20)

César Moro (Peruvian, 1903–56)
Letter to Emilio Adolfo Westphalen, 25 November 1941
Getty Research Institute, 2001.M.21 (box 1, folder 6)

### Wolfgang Paalen and Physics

Wolfgang Paalen (Austrian, 1905–59)
*Space Unbound,* 1941, oil on canvas, 114 × 145 cm (45 × 57 in.)
Lucid Art Foundation

Walter Reuter (German, 1906–2005)
Wolfgang Paalen in his studio, 1942, gelatin silver print from negative, 25.4 × 20.3 cm (10 × 8 in.)
Museo Franz Mayer, Archivo Wolfgang Paalen

Wolfgang Paalen (Austrian, 1905–59)
"The New Image," ca. 1942
From *Dyn,* no. 1 (1942): 7
Getty Research Institute, 84-S23

Wolfgang Paalen watching an indigenous artisan paint on cactus paper, n.d., gelatin silver print, 17.8 × 12.4 cm (7 × 4⅞ in.)
Museo Franz Mayer, Archivo Wolfgang Paalen

Wolfgang Paalen (Austrian, 1905–59)
Untitled (tipped-in print included in copies 21–60 of *Dyn,* no. 1 [1942]), n.d., hand-printed woodcut print on Chinese paper, signed and numbered 22/50, 25.4 × 19.1 cm (10 × 7½ in.)
Getty Research Institute, 980029 (box 1, folder 11)

Wolfgang Paalen (Austrian, 1905–59)
Tipped-in frontispiece print in César Moro, *Château de grisou* (Mexico City: Tigrondine, 1943), numbered 5/50
Getty Research Institute, 2001.M.21 (box 26, folder 3)

Diagram
From Erwin Schrödinger, *Abhandlungen zur Wellenmechanik* (Leipzig: Johann Ambrosus Barth, 1927), 57
Getty Research Institute, 90-B21193

Small stone figure found in the Bay of Bella-Bella, British Columbia
From *Dyn,* nos. 4–5 (1943): 13
Getty Research Institute, 84-S23

Wolfgang Paalen (Austrian, 1905–59)
Graphic used as illustration in "L'auto" by Charles Givors [Wolfgang Paalen]
From *Dyn,* no. 1 (1942): 46
Getty Research Institute, 2571-405

Wolfgang Paalen (Austrian, 1905–59)
*Space Person,* 1941
From *Dyn,* no. 3 (1942): after p. 12
Getty Research Institute, 84-S23

Graphic design based on Northwest American Indian totem carving
From *Dyn,* no. 2 (1942): 42
Getty Research Institute, 84-S23

John Dawson [Wolfgang Paalen] (Austrian, 1905–59)
*What the Sailor Will Say,* 1942
From *Dyn,* no. 1 (1942): 23
Getty Research Institute, 2571-405

Wooden box, Haida, collected by Wolfgang Paalen near Sitka, Alaska, half tone print, 10.2 × 15.2 cm (4 × 6 inches)
Photograph by Luis Limón Aragón
From *Dyn,* 4–5 (1943): 22

### Alice Rahon and Geology

Alice Rahon (French, 1904–87)
*Meeting of Rivers,* 1942, oil on canvas, 67.6 × 67.6 cm (26⅝ × 26⅝ in.)
Private collection

Marcel Jean (French, 1900–1994), André Breton (French, 1896–1966), and Jacqueline Breton (French, 1910–33)
Illustrations of geological formations
From *Minotaure,* no. 8 (1936): 20–21
Getty Research Institute, 84-S173

Eva Sulzer (Swiss, 1902–90)
Petroglyphs in Wrangell, Alaska, 1939, photographic print from original negative, 6.5 × 6 cm (2½ × 2⅜ in.)
Getty Research Institute, 2012. M.4

Alice Rahon (French, 1904–87)
*Poem-Painting,* 1939
From *Dyn,* no. 1 (1942): 35
Getty Research Institute, 84-S23

Alice Rahon (French, 1904–87)
Illustration of totem poles at the Skeena River from a sketch Rahon made at the Tsimshian village of Kispayax, ca. 1939
From *Dyn,* nos. 4–5 (1943): plate vi
Getty Research Institute, 84-S23

Alice Rahon (French, 1904–87)
*Crystals of Space,* 1943
From *Dyn,* no. 6 (1944): after p. 20
Getty Research Institute, 84-S23

Alice Rahon (French, 1904–87)
Title page and frontispiece print, ca. 1944, title page: 17.8 × 23.5 cm (7 × 9¼ in.); frontispiece: 22.9 × 17.1 cm (9 × 6¾ in.)
From César Moro, *Lettre d'amour* (Mexico City: Dyn, 1944), limited series 22/55
Getty Research Institute, 980029 (box 1, folder 9)

Alice Rahon and César Moro walking down the street in Mexico City, ca. 1942, gelatin silver print, 14 × 8.9 cm (5½ × 3½ in.)
Getty Research Institute, 2001.M.21 (box 9)

Wolfgang Paalen, Alice Rahon, and Gordon Onslow Ford in Paalen's studio, Los Cedros y Begonias, San Angel, Mexico, ca. 1942, gelatin silver print, 12.7 × 17.8 cm (5 × 7 in.)
Lucid Art Foundation

**Carlos Mérida and Archaeology**
Carlos Mérida (Guatemalan, 1891–1985)
*All in Rose,* 1943, oil on canvas mounted on board, 74.9 × 62.2 cm (29½ × 24½ in.)
Los Angeles County Museum of Art, Latin American Department, The Bernard and Edith Lewin Collection of Mexican Art, AC1997.LWN.417

Miguel Covarrubias (Mexican, 1904–57)
Black-and-white photograph of clay figurines from Tlatilco, ca. 1940, accompanying Covarrubias's text "Tlatilco: Archaic Mexican Art and Culture"
From *Dyn,* nos. 4–5 (1943): 41
Getty Research Institute, 84-S23

Incised design of an animal's claw on a small pot from Tlatilco
From Miguel Covarrubias, "Tlatilco: Archaic Mexican Art and Culture," *Dyn,* nos. 4–5 (1943): 46
Getty Research Institute, 84-S23

César Moro (Peruvian, 1903–56)
"Pierre Mère"
From *Dyn,* no. 2 (1942): 34–35
Getty Research Institute, 84-S23
Accompanied by English translation

Carlos Mérida (Guatemalan, 1891–1985)
*Drawing,* 1942
From *Dyn,* no. 2 (1942): 34–35
Getty Research Institute, 84-S23

Carlos Mérida (Guatemalan, 1891–1985)
Zacapoaxtlas march in native costumes in Huejotzingo, Puebla, Mexico, ca. 1940, color lithograph print, 44.5 × 31.8 cm (17½ × 12½ in.)
From *Carnival in Mexico* (Mexico City: Lithographic Department of the Talleres Gráficos de la Nación, 1940), plate 6
Getty Research Institute, 89-B18431

Carlos Mérida (Guatemalan, 1891–1985)
Girls dressed as elegant bourgeoisie in Santa Ana Chiautempan, Puebla, Mexico, ca. 1940, color lithograph print, 44.5 × 31.8 cm (17½ × 12½ in.)
From *Carnival in Mexico* (Mexico City: Lithographic Department of the Talleres Gráficos de la Nación, 1940), plate 7
Getty Research Institute, 89-B18431

Carlos Mérida (Guatemalan, 1891–1985)
People dressed as dogs for the Fiesta of Huchuenchis in Huixquilcan, Mexico, ca. 1940, color lithograph print, 44.5 × 31.8 cm (17½ × 12½ in.)
From *Carnival in Mexico* (Mexico City: Lithographic Department of the Talleres Gráficos de la Nación, 1940), plate 3
Getty Research Institute, 89-B18431

**Gordon Onslow Ford and Mathematics**
Gordon Onslow Ford (English, 1912–2003)
*The Marriage,* 1944, oil on canvas, framed: 109.9 × 76.2 cm (43¼ × 30 in.)
Private collection

Man Ray (American, 1890–1976)
*Various Types of Conical Points* and *Allure of the Elliptical Function P' (U) for G2=0 and G3=4*
From *Cahiers d'art* 11, nos. 1–2 (1936): 16–17
Getty Research Institute, 86-S596

Ceramic vessel from Capacha, Colima, Mexico, decorated with dots and incised lines in a "sunburst pattern," ca. 1500–1000 BCE
Photograph by Eduardo Williams

Gordon Onslow Ford (English, 1912–2003) and Jacqueline Johnson (American, 1905–76)
Postcard from Onslow Ford and Johnson to César Moro, ca. 1940, pen on paper, 9.5 × 14.6 cm (3¾ × 5¾ in.)
Getty Research Institute, 980029 (box 1, folder 18)

Jacqueline Johnson, Gordon Onslow Ford, Remedios Varo, and César Moro at El Molino, Eronguarícuaro, Mexico, ca. mid-1940s, gelatin silver print, 12.7 × 17.8 cm (5 × 7 in.)
Lucid Art Foundation

Wolfgang Paalen (Austrian, 1905–59)
Letter to Gordon Onslow Ford in which he mentions that André Breton could no longer pardon the existence of *Dyn,* June 1945
Lucid Art Foundation

**Manuel Alvarez Bravo, Doris Heyden, and Poetic Ethnography**
Museo Nacional de México
*Los tesoros del Museo Nacional de México: Escultura azteca,* photographs by Manuel Alvarez Bravo, prologue by Benjamin Péret (Mexico, 1943)
Getty Research Institute, 91-B17725

Manuel Alvarez Bravo (Mexican, 1902–2002)
Photograph of Kwakiutl painted wooden mask representing Tso-no-qoa, a female cannibalistic spirit of the forest
From *Dyn,* nos. 4–5 (1943): 26
Getty Research Institute, 84-S23

Layout featuring photographs by Manuel Alvarez Bravo (Mexican, 1902–2002) and text by André Breton (French, 1896–1966)
Left: *Recent Grave,* 1933; right: *After the Riot* (also known as *Striking Worker Murdered*), 1934, by Alvarez Bravo, accompanying Breton's text "Souvenir du Mexique"
From *Minotaure,* nos. 12–13 (1939): 30–31
Getty Research Institute, 84-S173

Raoul Ubac (Belgian, 1910–85)
*Portrait in a Mirror* and untitled photograph, ca. 1938
From *Minotaure,* no. 11 (1938): 16–17
Lucid Art Foundation

Manuel Alvarez Bravo (Mexican, 1902–2002)
*Recent Grave,* 1933, gelatin silver print, 16.5 × 24.3 cm (6½ × 9⁹⁄₁₆ in.)
J. Paul Getty Museum, 92.XM.23.21

Manuel Alvarez Bravo (Mexican, 1902–2002)
*Ladder of Ladders,* 1931, gelatin silver print, image: 24.2 × 18.9 cm (9½ × 7⁷⁄₁₆ in.); sheet: 25.3 × 20.1 cm (9¹⁵⁄₁₆ × 7¹⁵⁄₁₆ in.)
J. Paul Getty Museum, 2003.507.29

Manuel Alvarez Bravo (Mexican, 1902–2002)
*Portrait of the Eternal,* 1935, gelatin silver print, 24.3 × 19.2 cm (9⁹⁄₁₆ × 7⁹⁄₁₆ in.)
J. Paul Getty Museum, 92.XM.23.30

Manuel Alvarez Bravo (Mexican, 1902–2002)
*A Fish Called Sierra,* 1944, gelatin silver print, image: 24 × 17.4 cm (9⁷⁄₁₆ × 6⅞ in.); sheet: 25.2 × 20.2 cm (9¹⁵⁄₁₆ × 7¹⁵⁄₁₆ in.)
J. Paul Getty Museum, 2003.507.18

Manuel Alvarez Bravo (Mexican, 1902–2002)
*Fable of the Dog and the Cloud,* 1930–40, gelatin

silver print, 16.7 × 22.7 cm (6 ⅝ × 9 in.)
J. Paul Getty Museum, 92.XM.23.44

Doris Heyden (American, 1915–2005)
*Junio 1942,* 1942, gelatin silver print,
22.9 × 16.5 cm (9 × 6 ½ in.)
Museo Franz Mayer, Archivo Wolfgang Paalen

### Eva Sulzer and Ethnographic Landscapes
Eva Sulzer (Swiss, 1902–90)
*. . . when we opened the door of this great
"community house,"* 1939
From *Dyn,* no. 3 (1942): 30
Getty Research Institute, 2012.M.4

Eva Sulzer (Swiss, 1902–90)
*Pyramid of the Magician, Uxmal,* Yucatán,
Mexico, 1939, gelatin silver print,
20.6 × 19.7 cm (8 ⅛ × 7 ¾ in.)
Getty Research Institute, 2012.M.4

Eva Sulzer (Swiss, 1902–90)
*Sepent Head Sculpture, Yucatan,* 1939,
gelatin silver print, 19.5 × 20.5 cm
(7 ¾ × 8 ⅛ in.)
Getty Research Institute, 2012.M.4

Eva Sulzer with dog, n.d., gelatin silver print,
14.6 × 10.2 cm (5 ¾ × 4 in.)
Museo Franz Mayer, Archivo Wolfgang Paalen

*At Last It Is Truly the Forest* by Eva Sulzer
(Swiss, 1902–90), accompanying the essay
"Paysage totémique" by Wolfgang Paalen
(Austrian, 1905–59)
From *Dyn,* no. 2 (1942): 42–43
Getty Research Institute, 2003.M.46

Eva Sulzer (Swiss, 1902–90), Wolfgang
Paalen (Austrian, 1905–59), and Alice Rahon
(French, 1904–87)
Ten rolls of 8mm film documenting Wolfgang
Paalen's journey through British Columbia in
summer 1939, 8mm transferred to digital file,
3 min. excerpt, compiled by Andreas Neufert
Paalen Archiv Berlin, Succession Wolfgang
Paalen

Eva Sulzer (Swiss, 1902–90)
*Tsimshian Totem Poles at Kispayax,* British
Columbia, 1939, gelatin silver print,
13.9 × 13.8 cm (5 ½ × 5 ⅜ in.)
Getty Research Institute, 2012.M.4

George Mercer Dawson (Canadian, 1849–1901)
*Skidegate, an old village of the Haida Indians,*

*Queen Charlotte's Island, Canada,* 1878,
gelatin silver print, 20.7 × 25.5 cm
(8 ⅛ × 10 ⅛ in.)
Getty Research Institute, 2012.M.4

Eva Sulzer (Swiss, 1902–90)
*Convent of the Nuns, Uxmal,* 1939, gelatin
silver print, 21.3 × 18.4 cm (8 ⅜ × 7 ¼ in.)
Getty Research Institute, 2012.M.4

Eva Sulzer (Swiss, 1902–90)
*Wolfgang Paalen in Wrangell, Alaska,* 1939,
gelatin silver print, 25.4 x 20.4 cm
(10 × 8 ⅛ in.)
Getty Research Institute, 2012.M.4

*Childhood* by Eva Sulzer (Swiss, 1902–90)
accompanying the essay "A preface to Parker
Tyler's *America's Hallucinations*" by Henry
Miller (American, 1891–1980)
From *Dyn,* no. 3 (1942): after p. 34
Getty Research Institute, 84-S23

### Miguel Covarrubias, Rosa Rolando, and Ethnography and Indigenismo
Nicholas Murray (Hungarian, 1892–1965)
Miguel Covarrubias and Rosa Rolando,
ca. 1930, gelatin silver print, 24.1 × 19.4 cm
(9 ½ × 7 ⅝ in.)
Universidad de las Américas Puebla, Archivo
Miguel Covarrubias, Miguel y Rosa
Covarrubias I—Fotografías, acc. no. 27002

Rosa Rolando (American, 1895–1970)
Left: *Schoolgirl of Tehuantepec,* ca. 1943; right:
*Chontal Children of Huamelula, Oaxaca,*
ca. 1943
From *Dyn,* nos. 4–5 (1943): 66–67
Getty Research Institute, 2571-405

Miguel Covarrubias (Mexican, 1904–57)
*The Hall at Tepeaca*
From Bernal Díaz del Castillo, *The Discovery
and Conquest of Mexico, 1517–1521,* trans.
Alfred Percival Maudslay (Mexico City: Rafael
Loera y Chávez for members of the Limited
Editions Club, 1942), 188–89
Getty Research Institute, 2869-042

Miguel Covarrubias (Mexican, 1904–57)
*Archaic Figurines from Tlatilco,* ca. 1940
From *Dyn,* nos. 4–5 (1943): after p. 42
Lucid Art Foundation

Miguel Covarrubias (Mexican, 1904–57)
Watercolor drawing of a mask of hard wood
from Guerrero, Mexico, and four small jadeite

objects in the style of La Venta, ca. 1940
From *Dyn,* no. 6 (1944): after p. 24
Getty Research Institute, 84-S23

Photograph of Chief Shakes's totem screen,
1889, by Mrs. Ferry (probably Sarah Brown
Kellog Ferry [American, 1827–1912]); and
photograph of carved and painted Tlingit
partition screen from the ancient community
house of the Chief Shakes family, ca. 1940,
by Miguel Covarrubias (Mexican, 1904–57)
From *Dyn,* nos. 4–5 (1943): 16, plate iii
Lucid Art Foundation

View of Chief Shakes's partition screen in
Wolfgang Paalen's studio at Villa Obregon,
ca. 1944, gelatin silver print, 17.6 × 12.5 cm
(6 ⅞ × 4 ⅞ in.)
Paalen Archiv Berlin, Succession Wolfgang
Paalen

### Robert Motherwell and Dyn
Peter A. Juley & Son photography firm
(New York, 1896–1975)
Robert Motherwell in his Greenwich Village
studio with *Collage in Beige and Black* (left)
and *Wall Painting with Stripes* (right),
ca. 1943, photographic print, 20.3 × 25.4 cm
(8 × 10 in.)
Smithsonian American Art Museum,
Photographic Archives, Peter A. Juley & Son
Collection, J0004981

Robert Motherwell (American, 1915–91)
*The Room,* 1944
From *Dyn,* no. 6 (1944): after p. 10
Getty Research Institute, 84-S23

Robert Motherwell, ed. (American, 1915–91)
*Possibilities* (New York: Wittenborn & Schultz,
1947)
Getty Research Institute, 85-S138

Lee Sievan (American, 1907–90)
Photograph of Robert Motherwell at the
"Aesthetics and the Artist" conference,
Woodstock, New York, 1952, gelatin silver
print, 25.4 × 20.3 cm (10 × 8 in.)
Getty Research Institute, 2003.M.23
(box 5, folder 23)

Robert Motherwell (American, 1915–91)
Letter to Irving Sandler, 23 February 1970
Getty Research Institute, 2000.M.43
(box 22, folder 23)

**Dawn Ades** is a semiretired professor of art history and theory at the University of Essex, a Fellow of the British Academy, a former trustee of Tate, and the recipient of an OBE (2002) for her contributions to art history. She has curated or cocurated important international exhibitions over the past thirty years, including *Dada and Surrealism Reviewed* (with D. Sylvester and E. Cowling) (1978), *Art in Latin America: The Modern Era, 1820–1980* (1989), *Art and Power: Europe under the Dictators* (1994), *Fetishism: Visualising Power and Desire* (1995), *Salvador Dalí: Centenary* (2004), *Undercover Surrealism: Georges Bataille and Documents* (with Simon Baker) (2006), and many others. In addition to exhibition catalogs, she has published extensively on Dada, surrealism, women artists, and Mexican muralists; her books include *Photomontage* (1976; rev. 1986), *Salvador Dalí* (1982; rev. 1990), *André Masson* (1994), and *Figures and Likenesses: The Painting of Siron Franco* (1996).

**Donna Conwell** is associate curator at Montalvo Arts Center in Saratoga, California; she was project specialist in the Department of Architecture and Contemporary Art at the Getty Research Institute from 2008 to 2011, where she worked on two research projects: Pacific Standard Time and Surrealism in Latin America. She has curated and cocurated contemporary art exhibitions and performances for such organizations as inSite, the Fellows of Contemporary Art, Museo Universitario de Arte Contemporáneo, and the Getty Research Institute. Her writing has been published in *X-TRA*, the *Getty Research Journal, Latinart.com,* and exhibition catalogs.

**Annette Leddy,** a senior cataloger and consulting curator at the Getty Research Institute, has written catalog essays on contemporary artists Larry Bell, Allan Kaprow, and William Leavitt; journal articles on Italian futurist Angelo Rognoni, Chilean writer Roberto Bolaño, Argentine writer Jorge Luis Borges, and Mexican artist Francis Alÿs; and assorted reviews on art and literature. In 2009, she was awarded a Warhol Foundation Arts Writer grant and was a finalist for the Frieze Writer's Prize. In 2006, Leddy cocurated a GRI exhibition on the visual poems of the Italian futurists. She is a participant in the GRI Surrealism in Latin America project.

**Rebecca Zamora** is a member of the scholars program at the Getty Research Institute and was research assistant for the Surrealism in Latin America project in 2007–2010. She received her MA in Latin American Studies at the University of California, Los Angeles, with a thesis on the subject of David Alfaro Siqueiros's murals in Los Angeles. She has compiled bibliographies for the seminar "Lawrence Alloway Reconsidered" at the Tate Britain and for the publication *Anglo-American Exchange in Postwar Sculpture, 1945–1975* (2011). Zamora also created the research guide for the Surrealism in Latin America project at the GRI.

# ILLUSTRATION CREDITS

Photographs of items in the holdings of the Getty Research Institute are courtesy the Research Library.

Every effort has been made to identify and contact the copyright holders of images published in this book. Should you discover what you consider to be a photo by a known photographer, please contact the publisher.

The following sources have granted additional permission to reproduce illustrations in this book:

**Introduction**
**Fig. 1** © 2011 Artists Rights Society (ARS), New York / ADAGP, Paris

**Fig. 2** © 2011 Orange County Citizens Foundation / Artists Rights Society (ARS), New York

**Fig. 3** Courtesy James Speck

**Leddy**
**Figs. 2–9** © Succession Wolfgang Paalen, Paalen Archiv Berlin

**Figs. 11, 12** Copyright 2011 Edda Renouf

**Fig. 13** © Succession Wolfgang Paalen and Eva Sulzer

**Figs. 14–16** Oscar Román. Courtesy of Oscar Román gallery

**Fig. 17** Copyright María Elena Rico Covarrubias

**Fig. 18** © Alma Mérida

**Fig. 20** Private collection

**Fig. 21** © Eduardo Williams, courtesy Foundation for the Advancement of Mesoamerican Studies, Inc., www.famsi.org

**Fig. 22** Collección Museo Franz Mayer

**Conwell**
**Fig. 1** Poem: Oscar Román. Courtesy of Oscar Román gallery. Image: Courtesy Dennis Brehme

**Figs. 2–4** © Succession Wolfgang Paalen and Eva Sulzer

**Fig. 6** Art: © The Brassaï Estate–RMN. Photo: © RMN/ Art Resource, NY/Michèle Bellot

**Fig. 7** Collección Museo Franz Mayer. Courtesy Dennis Brehme

**Fig. 8** Courtesy Archivo Fotografico Martín Chambi, Cuzco, Peru. www.martinchambi.org

**Fig. 9** Courtesy Casa Luis Barragán

**Fig. 10** Top: Copyright María Elena Rico Covarrubias. Bottom: Arizona State Museum, University of Arizona, Donald Cordry, Photographer

**Figs. 11, 19** Copyright María Elena Rico Covarrubias

**Fig. 12** Archivo Miguel Covarrubias, Sala de Archivos y Collecciones Especiales, Fundación Universidad de las Américas Puebla. Courtesy Casa Luis Barragán

**Figs. 13, 15** © Colette Urbajtel / Asociación Manuel Álvarez Bravo AC

**Fig. 14** © 2011 Artists Rights Society (ARS), New York / ADAGP, Paris

**Fig. 16** © Alma Mérida

**Fig. 17** Courtesy Dennis Brehme. Image courtesy the Bancroft Library, University of California, Berkeley

**Fig. 18** Courtesy Laurencia Álvarez

*Surrealism in Latin America: Vivísimo Muerto*
Edited by Dawn Ades, Rita Eder, and Graciela Speranza
ISBN 978-1-60606-117-6 (paper)

*Pacific Standard Time: Los Angeles Art, 1945–1980*
Edited by Rebecca Peabody, Andrew Perchuk, Glenn Phillips,
and Rani Singh, with Lucy Bradnock
ISBN 978-1-60606-072-8 (hardcover)

*Display and Art History: The Düsseldorf Gallery and
Its Catalogue*
Thomas W. Gaehtgens and Louis Marchesano
ISBN 978-1-60606-092-6 (paper)

*Brush and Shutter: Early Photography in China*
Edited by Jeffrey Cody and Frances Terpak
ISBN 978-1-60606-054-4 (hardcover)

*G: An Avant-Garde Journal of Art, Architecture, Design,
and Film, 1923–1926*
Edited by Detlef Mertins and Michael W. Jennings
Translation by Steven Lindberg with Margareta Ingrid
Christian
ISBN 978-1-60606-039-1 (hardcover)

*The Aztec Calendar Stone*
Edited by Khristaan D. Villela and Mary Ellen Miller
ISBN 978-1-60606-004-9 (hardcover)

*Printing the Grand Manner: Charles Le Brun and
Monumental Prints in the Age of Louis XIV*
Louis Marchesano and Christian Michel
ISBN 978-0-89236-980-5 (hardcover)

*Visual Planning and the Picturesque*
Edited by Mathew Aitchison, with texts by Nikolaus Pevsner,
John Macarthur, and Mathew Aitchison
ISBN 978-1-60606-001-8 (hardcover)

*Walls of Algiers: Narratives of the City through Text
and Image*
Edited by Zeynep Çelik, Julia Clancy Smith, and Frances Terpak
Copublished with University of Washington Press
ISBN 978-0-29598-868-9 (paper)

*Meyer Schapiro Abroad: Letters to Lillian and Travel
Notebooks*
Edited by Daniel Esterman
ISBN 978-0-89236-893-8 (hardcover)

*California Video: Artists and Histories*
Edited by Glenn Phillips
ISBN 978-0-89236-922-5 (hardcover)

*Dilettanti: The Antic and the Antique in Eighteenth-
Century England*
Bruce Redford
ISBN 978-0-89236-924-9 (hardcover)

*The Getty Murúa: Essays on the Making of Martín
de Murúa's "Historia General del Piru," J. Paul Getty
Museum Ms. Ludwig XIII 16*
Edited by Thomas B. F. Cummins and Barbara Anderson
ISBN 978-0-89236-894-5 (hardcover)

*China on Paper: European and Chinese Works from
the Late Sixteenth to the Early Nineteenth Century*
Edited by Marcia Reed and Paola Demattè
978-1-60606-068-1 (paper)

*Art, Anti-Art, Non-Art: Experimentations in the Public
Sphere in Postwar Japan, 1950–1970*
Edited by Charles Merewether with Rika Iezumi Hiro
ISBN 978-0-89236-866-2 (hardcover)

*Lucien Hervé: Building Images*
Olivier Beer
ISBN 978-0-89236-754-2 (hardcover)

*Had gadya: The Only Kid: Facsimile of El Lissitzky's
Edition of 1919*
Edited by Arnold J. Band
ISBN 978-0-89236-744-3 (paper)

*Aldo Rossi: I quaderni azzurri*
Aldo Rossi
ISBN 978-0-89236-589-0 (boxed set)

*Devices of Wonder: From the World in a Box to Images
on a Screen*
Barbara Maria Stafford and Frances Terpak
ISBN 978-0-89236-590-6 (paper)